24.99

MINI...HTING

Techniques for
...o Photography

Kirk Tuck

AMHERST MEDIA, INC. ■ BUFFALO, NY

Published by:
Amherst Media, Inc.
P.O. Box 586
Buffalo, N.Y. 14226
Fax: 716-874-4508
www.AmherstMedia.com

Publisher: Craig Alesse
Senior Editor/Production Manager: Michelle Perkins
Assistant Editor: Barbara A. Lynch-Johnt
Editorial Assistance from: John S. Loder, Charles Schweizer

ISBN-13: 978-1-58428-250-1
Library of Congress Control Number: 2008942235
Printed in Korea.
10 9 8 7 6 5 4 3 2 1

Introduction

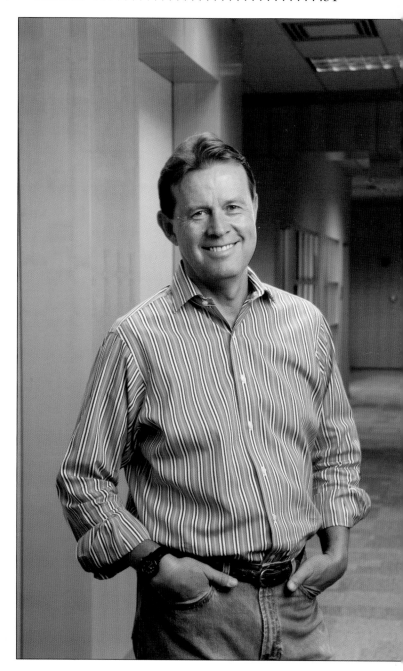

About the Author

Photo of the author taken at the Austin Lyric Opera in Austin, TX.

Kirk Tuck attended the University of Texas where he dabbled in electrical engineering and English literature before accepting a position as a specialist lecturer teaching photography in the University of Texas College of Fine Arts. Soon, he was lured into the world of advertising and served for seven years as the creative director for Avanti Advertising and Design, where he won awards for radio, television, and print campaigns. In the late 1980s, he decided to become a freelance photographer, a career he has enjoyed ever since. Kirk's clients include IBM, Tivoli Systems, Dell Computer, Motorola, AMD, Freescale Semiconductor, *Elle* magazine, *Private Clubs* magazine, Time Warner, Pharmaco, PPD, JSR, The Arts Council of Texas, Southwest Water Company, Adventure Tours, and many advertising agencies. He resides in Austin, TX.

Dedication

I would like to dedicate this book to the photographers who whetted my appetite to learn more about lighting and about the "why" of photography, not just the "how to." First and foremost is Richard Avedon, perhaps the greatest photographer of the twentieth century. Then, I must credit Irving Penn, Guy Bourdin, Chris Von Wagenheim, Arthur Elgort, and, of course, Chris Callis. Everything we see today was essentially pioneered by these photographers decades ago—all with much more recalcitrant tools and without the ready "reference" of the web. We stand (shakily) on the shoulders of giants.

Acknowledgments

I must thank my dear and patient friend Anne Butler for her keen guidance and her indulgence in sitting for my many photographic experiments. Thanks also go to Paul Bardagjy, a brilliant architectural photographer whose business insight and technical virtuosity keep the business interesting for me, and to Amy Smith for her able assistance and keen eye. Special thanks go to the swimmers and coaches of Weiss and Weiss Aquatics at the Rollingwood Pool, with whom I swim. They don't necessarily care what you do outside the pool, but in the pool you are always family. Finally, I must thank my wife Belinda and my son Benjamin for their endless support and patience. They are both correct: tagging along on a corporate shoot is not a family vacation.

Preface

This is, first and foremost, a book about lighting. I firmly believe that if you know the basic principles of lighting you can light just about anything you can fit in your studio with almost any light source—from a flashlight, to a 60W light bulb, to the usual studio electronic flash lighting. In the course of this book, you'll see examples created using battery-operated, hot-shoe mounted flashes; tungsten fixtures (those designed for photography and those you can buy at the well stocked hardware store); fluorescent light fixtures; inexpensive Alien Bees electronic flashes; and the more "professional" Profoto studio flash equipment.

In no way do I advise you to use a light or accessory just because I happened to buy a particular product on a whim. In nearly every case, an expensive item used to create a look could easily be replaced by a more budget-conscious item with no impact on the quality of the image. If I use a Profoto light in a setup, it may be that I've misplaced the Alien Bees light or Nikon flash I was intending to use and expediency suggested going with the nearest option. Some of the gear I use was also purchased over a decade ago, before less expensive options became available.

The underlying idea is that you can be proficient with just about any light source once you understand how light works. In photography, invention and creativity trump sheer spending ability in almost every contest. I come from the school of thought that photographers work hard and long to create their own individual look or style—even while using the same mainstream cameras and lighting equipment everyone else does.

I learned a lot when I wrote my first book about photography. I learned that some people want an infinite amount of detail and painstaking, step-by-step "how to" information. Others just want to see examples with lighting diagrams. I think that knowing the reason *why* things are lit or photographed in a certain way may be even more enlightening to the majority of readers. Therefore, in this book I'll show you how I use the equipment I do and try to explain why I light my subjects the way I do. That means I won't show you hard-lit photos, using multiple fill flashes at sunset, or a model with her hair on fire. If that's the kind of work you want to do, though, the lighting theory in this book will still point you in the right direction. I'm not interested in duplicating the range and diversity of all the images you might find on a photo-sharing web site. Every example in this book comes from an actual assignment, was shot to illustrate an idea in this book, or was created on a self-assigned project that I truly enjoyed shooting. I hope you'll like the information and the stories. —*Kirk Tuck*

Photographers work hard and long to create their own individual look or style . . .

Introduction

If you know a group of photographers, you probably realize that some of them never want to step foot in a studio. These are the guys who spend hours camping on the side of a mountain in the bitter cold, waiting for the sun to peek over some far horizon and kiss the face of a picturesque cliff with a beam or two of juicy, golden sunlight. These are the same guys who have lost a toe or two to frostbite while waiting for a rare fox to creep out of a winter lair in search of food—the hardy ones who own multiple thermos bottles and lots of scratchy long underwear.

The rest of us, on the other hand, relish sleeping in our warm, cozy beds, grabbing a hot cup of coffee in the morning, and then walking into a bright, efficient studio space filled with fun lights and beautiful things to shoot. We are resolutely studio photographers. We want to create images at our leisure—and if we have an image in mind, we want to be able to play with all the lighting tools at our disposal to get just the effect we first visualized. And if you're like most of us, you'll keep at it until you make it work. This doesn't mean that we're adverse to occasionally stumbling around outside with cameras in hand . . . we just don't make a habit of it. So, if you're the kind of photographer who loves to experiment with light, relishes repeatable results, and also wants to be able to work regardless of inclement weather, then you are probably interested in having a studio and working with your own lights.

In years past, working in the studio with lighting could be a very expensive proposition.

A New World

In years past, working in the studio with lighting could be a very expensive proposition. Fortunately, the playing field has changed and effective lighting instruments, especially when used in conjunction with the new generations of digital cameras, have become very affordable.

Today, lighting effects that used to require quite a lot of flash power—to be photographed with film cameras and the slow film stocks generally used by studio photographers—can now be done with much lower-powered lights. With the current generation of advanced and professional digital cameras from manufacturers such as Nikon, Canon, Sony, and Pentax, many of the lighting techniques that required A/C-powered electronic flashes can now be replicated with simple, battery-operated strobes. The trick is to use the new cameras at higher ISO settings instead of throwing more light at a subject. Most of the new cameras yield cleaner and more saturated files when set at ISO 800 than film did at ISO 100—and each doubling of ISO cuts your power needs in half.

This new paradigm has not been lost on the manufacturers of traditional electronic flash and studio products. These are the companies that make flashes that need to be plugged into the wall (and the equipment that supports them). They've looked at the rapidly increasing number of photographers who are interested in studio lighting and realized that there is a much bigger market for their products among interested hobbyists and new professionals than there is in the traditional (and declining) "big studio/high power" market.

One of the first companies to realize that a shift toward less expensive lighting was occurring was the Paul C. Buff company, which began marketing a wonderfully subversive product line called Alien Bees. These are inexpensive, low- and medium-powered A/C monolight flashes (meaning they are self-contained flashes rather than packs with separate heads [see pages 50–53 for more on this) created using new materials, such as formed Lexan plastic. They are designed specifically for photographers who want to experiment with all kinds of studio lighting without having to take out a second mortgage. Time has proven that the thinking behind the Alien Bees product was sound; it *is* possible to make an inexpensive studio light that is both reliable and as capable as lights costing hundreds or thousands of dollars more. Like most good ideas, the Alien Bees concept was quickly copied by a number of other manufacturers, including Norman, Elinchrome, and Calumet.

While premium brands of electronic lighting equipment, like Broncolor and Profoto, confer a certain amount of status on their owners, the reality is much like that in the current camera market: for 95 percent of

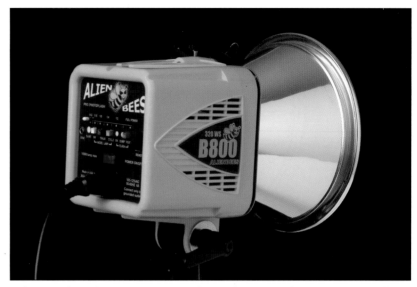

Side view of an Alien Bees B800 monolight. This is one of a new category of inexpensive studio lights aimed at a wide range of photographers, from hobbyist to professional. This unit offers plenty of power, good recycling times, and an easy-to-use interface.

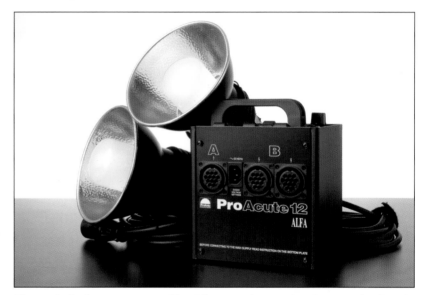

Electronic flash systems are offered by many international companies but the "gold standard" for rental houses, fashion photographers, and those requiring utterly dependable and consistent performance, are the various units from Profoto of Sweden. Shown here is their less expensive Acute-series studio flash system consisting of a strobe generator, or "power pack," and two of their fan-cooled Acute flash heads.

all projects (especially studio projects) midrange products are equal to flagship products—at least as far as the actual images are concerned. In the Nikon line, spending two and a half times the money to get a D3 instead of a D300 doesn't buy you more pixels or a sharper, better image at ISO 200–800, it buys you a faster frame rate (useless in a studio when working with flash) and a full-frame sen-

sor. A quick look at test images from both cameras shot in good light (the kind you'll make in your studio) reveals little or no difference. Some Canon pros actually feel that the Canon 5D outputs a *better* image file than the Canon 1DS Mark II—at less than a third of the price. The same is now true in lighting; the difference in price between a Broncolor light and an Alien Bees light may be thousands of dollars, but the difference in performance between the two might be a little tighter voltage regulation (meaning an exposure that is slightly more precisely repeatable, frame after frame), a more robust build quality, and . . . well, that's about it.

What does all this mean? Well, for all of us who work within realistic budgets, it means a wide choice of great tools available for budget prices. It means that having a workable studio is within your grasp. One assistant I worked with remarked that he would love to do more studio lighting projects if he could just afford the initial investment in equipment. He and I put together a list of gear that he thought would be the minimum required to do his art. He looked at the total cost and felt disheartened. I looked at the total cost and realized that it was less than his cable television bill for the year. Think about it—all that money for hundreds of channels of boring programming, or a full set of studio lights that may provide a decade or more of (possibly money-generating) use.

Twenty years ago, the choices were stark for the serious shooter: pony up big time for the power and accessories you needed, or resign yourself to shooting only in available light. Now, a workable studio lighting setup is in your grasp for the price of one large Starbuck's latté a day for one year.

In the following chapters, we'll look at what kind of equipment works best for different kinds of work and how to make it all come together on a budget and in a limited amount of space. The word "budget" is relative, of course. Some of you will think nothing of pulling out your checkbook and quickly acquiring the best gear made. Some of you will be more circumspect. Some of you are downright cheap and will look for every opportunity to substitute less expensive, alternative solutions. This book is for all of you, though, because the principles of lighting remain the same no matter what the price tag on the light you use.

With the wild fluctuations of currencies, I've settled on the medium-sized Starbuck's latté as a stable cross-currency pricing standard. Better than assigning a current dollar value to gear . . .

We'll explore the different uses for continuous (tungsten and fluorescent) lights and flash. We'll figure out how to use cheap, battery-operated strobes, and we'll figure out how and why to move up to A/C powered strobes. In the course of our mutual exploration, you'll eventually find a level that satisfies your personal vision. When you get there, stop buying new gear and read along to learn more about controlling the light you have. I'll show you how I light portraits in a number of ways, as well as how I light still lifes. The examples aren't intended to be the last word on style or lighting, they're meant to be a starting point for your experimentation—and they'll show you basic principles of using light and controlling light.

Photography is a great undertaking for people who enjoy the journey. You could light a portrait every day for the rest of your life, and each day you would be able to find a different way to express your art. That's the real secret of studio

lighting: you can do truly amazing photography with even the simplest lights if you know the basic principles involved.

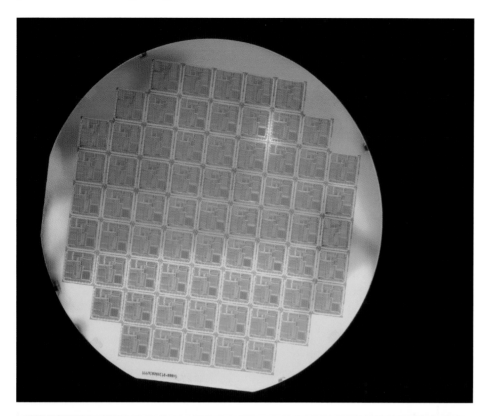

The shiny surface of a wafer (a silicon disk used as a substrate in integrated circuits) acts as a mirror, so to create a color pattern on it, you actually have to create a color pattern that can be reflected onto the shiny surface. We got a 16x20-inch picture frame, cut filters into the shapes we wanted, then placed the frame far enough away to put all of the filter edges totally out of focus. I shot directly into the wafer but used a shift lens so that the reflection of the camera would not show.

This bare wafer was shot for Motorola. It's a classic background glow shot (for more on this see pages 101–4). The foreground was lit by a small softbox placed directly overhead and used close in to provide good falloff (see pages 33–36). A small, bare light was added from slightly behind the wafer on camera left to give a little edge glow to one side.

1. The Inside Story on Lighting Inside

What's so great about a studio? Traditionally, the artist's studio is a refuge from the everyday details of life. It is a space in which you can be creative. Having a dedicated space buffers you from intrusions by family and friends and gives you the privacy to experiment with lighting and subjects that may be silly or serious. If you are a glamour photographer or a portrait photographer, you already know that the privacy of a good interior space trumps a public venue any day of the week.

The most important reason to have a studio, however, is to have a space where you are in charge of all the variables. *You* decide where to place your main light, *you* control how much fill light you are willing to allow, and *you* determine exactly what shade your background will be. Rather than "taking" a photograph you will be "making" the photograph. You'll never have to worry about the light changing while you finesse a small detail. You'll never have to worry about being accosted by curious people in the streets, and you'll never have to put your shoot with the supermodel on hold just because of a little rain.

What Constitutes a Studio?

Before we get any further, let's define what we mean when we say "studio." My definition is this: a studio is just about any interior space that gives you shelter from the elements and enough space for you to be able to put your camera the right distance from your subject and your subject the right distance from your background.

Space Considerations. If you do macrophotography you probably need only 100 square feet. The smallest space in which I can get a good, single person, head-and-shoulders portrait shot is about 400 square feet. If you routinely shoot groups of people or large sets, you'll probably need between 600 and 800 square feet or more.

My first studio space (indulge me for a few paragraphs here) was in Austin, TX. I was just starting out as a photographer and needed a space where I could shoot, soup film, and sleep—but like almost every new photographer, I had a lot more vision than cash. An acquaintance told me about an artists' cooperative in an old, downtown building called the California Hotel. Built back in the 1930s, the building had never been air conditioned and had sat unused for a number of years after a series of grisly, unsolved murders had been committed in the upstairs hallway. The police chalk marks, outlining where the victims had fallen, were still on the floors when I moved in. My space measured fourteen feet by thirty feet but

The most important reason to have a studio is to have a space where you are in charge of all the variables.

This photograph of Belinda is one of my very first portrait attempts, taken in my tiny, first studio space. The only light is the indirect light though a window to the right of the camera. No other lights or fill cards were used. The camera was an old Mamiya 220 twin-lens camera I bought for next to nothing. This image started me down the road to my career as a photographer.

the attraction was the twelve-foot ceilings. In a long downstairs space, we created a cooperative gallery in which artists could hang shows. During the summer months, I made sure that all of my portrait commissions were either in people's homes or at some air-conditioned venue, as the temperature in my space sometimes hit the century mark and no number of box fans brought relief.

During the fall and winter, the space worked well and the thick walls did a good job of holding in the heat generated by my small space heater. These were good times for doing headshots in the space. I shot potential rock stars, starving actors, and any number of artists and their work using three Vivitar 283 flashes with A/C adapters, a few threadbare white umbrellas, and an ancient Mamiya C220 medium-format twin-lens camera. Black & white film got souped by hand down the hall, while color film went out to a lab. I "Polaroided" with a cheap plastic Polaroid camera. At night, I'd roll out my futon and sleep on the floor. In the morning, I'd roll up the futon and stash it behind a home-dyed background and then brace myself for quick shower in the hotel's cold-water, outdoor shower, located discretely in the courtyard.

In a long downstairs space, we created a cooperative gallery in which artists could hang shows.

Looking back, I'm amazed at the work I did in such a primitive facility. But it proved to me that any space could work—given the need to make it work and a little ingenuity.

Later in my career, I worked in a studio that was nearly twenty-five hundred square feet and it was wonderful. Paying the monthly rent, however, was less wonderful. Twelve years ago, my wife and I bought a house that came with a separated two-car garage structure. The garage itself was 440 square feet, but it also had an additional 100 square feet of storage space at one end. The feature I liked best was a high ceiling that peaked at fourteen feet. I took one look at the garage and my brain said, "Potential studio space." We hired a contractor and began reshaping the garage into a workshop/office/studio.

I've worked there for the last twelve years. In that time, there have been maybe twenty or thirty jobs that required more square footage to pull off, but I've shot hundreds and hundreds of portraits and commercial projects in those 440 square feet.

This is a standard public-relations portrait for a medical professional (Dr. Poag), which was shot in our studio. Even though the shooting area itself is barely 400 square feet, it is more than adequate for most portrait work.

When a photograph requires more space, I have two options: I can rent larger space for the day from local photographers who still maintain larger spaces, or I can clear the furniture out of my living room and take advantage of a room that is 40x24 feet with high ceilings. In a pinch, any room can be a studio if you are able to make it work for your purposes.

Other Amenities. Ideally, you want a space where you can leave your lights and backgrounds set up for a few days at a time. Although much of my work today is done on location, I love having a creative space so I can keep my favorite lighting setup in place. That way, if I see a perfect face while I'm out and about, I can invite the subject right back to the studio and get to work. Considering that constructing most lighting setups takes at least half an hour (and an equal amount of time to take down and pack up), I figure that leaving everything set up saves me an hour each time I do a portrait.

You'll also want a space that's air conditioned in the summer and heated in the winter. And, if you use any light source other than battery-operated strobes, you'll want a source of safe and reliable electrical power.

This portrait of Benjamin was shot using one of my favorite two-light techniques with a twist. The main light is a 1000W tungsten fixture through two layers of diffusion material on a 48x48-inch frame. I placed a 48x48-inch black light blocker on the opposite side of the subject, and lit the background with the 100W modeling light of an Alien Bees B800 flash with a standard reflector. I shot the image on a Kodak DCS SLR/n, with a Nikon 105mm lens that had an 80B filter attached.

(It's also nice to be close to your favorite coffee house, but that's just a sybaritic coffee addict's point of view.)

What Kind of Photography Requires a Studio?

The two kinds of work that call for studios: classic portrait photography and still-life/product photography.

Classic Portraits. Classic portraiture, and people photos in general, are all about studio lighting. If you aspire to be the next Richard Avedon or Irving Penn, you'll almost certainly want a studio to shoot in. You'll be able to carefully and repeatably set up the kind of lighting that is a signature of your style. You'll control all the technical variables, like the color temperature of the light and whether it comes from large diffuse sources or small spotlights that provide exceptional contrast and detail. You'll be able to light the background exactly the way it should be in relation to the rest of the image, and you'll be able to offer the same style over and over again with every expectation that your light will be consistent.

I consider glamour and nude photography to be a subset of portrait work, and in these fields you will need the privacy provided by a studio space. You'll also appreciate being able to design intricate lighting designs. Much of learning to light well depends on trial and error.

Classic portraiture, and people photos in general, are all about studio lighting.

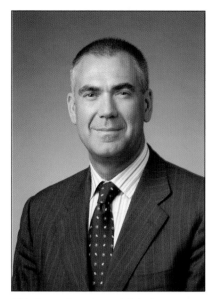

This is my favorite quick lighting setup for business and executive portraits. It consistes of one large light source to the left of the camera, a passive fill card to the right of the camera, and a small softbox as a background light.

The requirements for a good portrait studio are:

1. The space should feel comfortable to you and your subjects. It should be cool in the summer and warm in the winter. It should feel like a safe space, which for most subjects means that it should be open, uncluttered, and well lit.

2. It should provide enough space to do the kind of work you want to do. A minimum of twenty unobstructed feet will be required in order to do a nice portrait. The ceilings must be high enough to allow lights to be placed five or six feet above the heads of your subjects. The studio should also be wide enough to accommodate big softboxes on each side of your sitter.

3. You'll want to make sure that the walls and ceiling are painted a neutral white, gray, or black so that you don't create color casts in the faces of your subjects.

4. If you shoot glamour, fashion, or nudes, you'll need a changing area that gives your models privacy.

Still-Life and Product Photography. Still-life and product photography also beg for a studio. The success of these images depends on many variables, such as great propping, interesting composition, and good camera skills—but the primary requirement is really good lighting, and good lighting means different lighting for each different kind of subject surface and shape.

You'll need the same control over your environment as the portrait photographer, but there is one bonus: if you shoot things that don't move and don't melt, you can use inexpensive tungsten lights to do lots of different effects. This will allow you to better visualize what the light really looks like; because it is a con-

These fossils were photographed for Texas Monthly Magazine. This is a fun example of taking an ordinary assignment to a different level. This was shot looking down onto a white Plexiglas sheet set up on sawhorses. The red glow comes from gels placed over the lights below the sheet of Plexiglas.

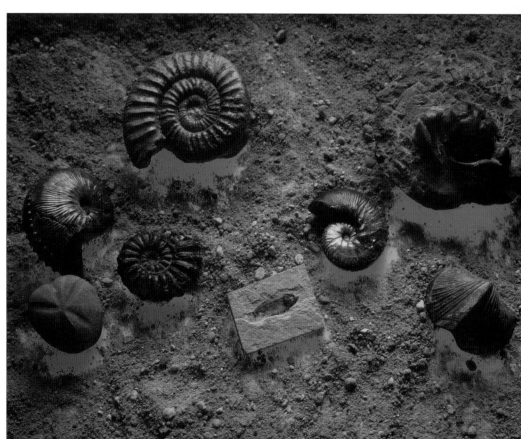

tinuous source, tungsten light is "what you see is what you get" lighting. (Contrast this with flash, which generally happens in hundredths or thousandths of a second, meaning that the only way to tell what the final product really looks like is to use Polaroid or consult the LCD panel on the back of your camera.)

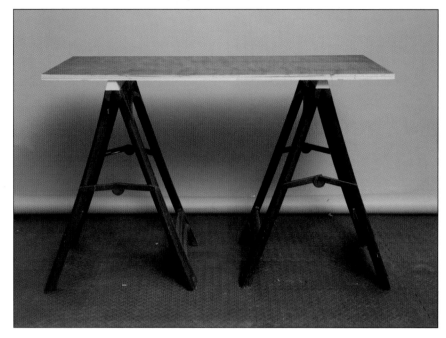

Still-life and product photography don't require a fancy space or fancy lighting equipment, but you will want a few pieces of furniture to make life easier. The first is a large, sturdy table upon which to place the objects of your photographic affection. Because I only need a table every other month or so, I've chosen to use two plastic sawhorses and a large piece of plywood as my work table.

Since you'll spend a lot of time looking through a camera trying to get everything just right, I also suggest a really good adjustable stool to sit on while you ponder the viewfinder. When we discuss still-life lighting in detail (see chapter 6), we'll talk about some of the other tools that make your life as a studio photographer easier.

Nothing fancy for my shooting table—just two plastic sawhorses from the hardware store and a convenient sheet of plywood. One advantage of this setup is that you can adjust the size of the plywood to the job.

For a professional still-life/product photographer, it is especially important to be able to leave a set intact for a day or so. In advertising, the art director normally comes to your studio while you set up and shoot. He or she will be there to suggest choices and to (tentatively) approve the final setups. In the good old days, we would always have the art director sign the backs of our Polaroid test shots to signify that he approved the final shot. Now, we show our art directors the final images on our computer screens or the LCDs on the back of the shooting camera.

We are generally given to understand that the art director's approval signifies the end of the shoot—but not so fast! In many situations, the art director will go back to his office very satisfied and turn over samples to the account executive, who will in turn will show them to the client. While the art director understood the shoot to be over, the client often sees this period as their last opportunity to make "a few adjustments" to the shot. A good account executive will explain to the client that their opportunity for input is past, but there seem not to be very many good account executives out in the real world. It always seems easier to tell the client, "Yes!" If your still life is still set up and ready when the art director calls with his hat in his hand and wants to know if you could just shoot "one teeny little variation," you'll save yourself a lot of work. That requires a studio that you can leave undisturbed. (Trust me—I learned this through many repetitions of doing things the hard way.)

Trust me—I learned this through many repetitions of doing things the hard way.

The basic requirements for a still-life/product photography studio are:

1. Enough room to get lights in front of, behind, and all around your subject.
2. The ability to block off exterior light (sunlight, etc.) so that you can control all of the light striking your subjects. This way, you have absolute control over lighting ratios and color temperatures.
3. Conveniently located wall sockets for your lights.
4. Lots of shelves and storage to keep the lighting accessories you will invent, the props you just can't bear to throw away, and the lighting support gear that tends to grow and reproduce on its own.

This way, you have absolute control over lighting ratios and color temperatures.

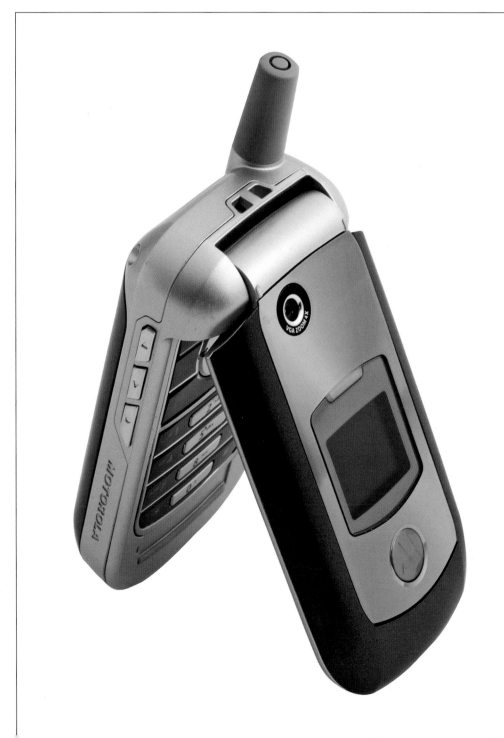

This image of a Motorola cell phone is a typical product shot, created against a white background. Images like this can be photographed easily in a small studio space with very basic equipment.

Getting Started

The first step is to identify a space you can use for your photography. If you're just starting out, you'll probably want to identify some space you already have and modify it for the kind of photography you'd like to do. Keep in mind that rooms can be schizophrenic—they are studios some of the time and living rooms, basements, and spare bedrooms the rest of the time.

Obstacles. The two biggest obstacles you'll need to overcome are going to be size and ceiling height. If you live in an urban area, you're more likely to have limitations about the space available to you. This will make you either more inventive or more frustrated. It's always a trade-off.

The next biggest obstacle may be the people who share your space with you. If you are using a room in a house you share with someone else, you'll probably want to be able to pack your stuff up when you've finished and store it somewhere. (This is definitely not a book on interpersonal relations, so you'll have to work those details out on your own.) If you are like some of my friends who live by themselves, you'll just leave it set up.

Design Objectives. When I started planning my current space, I had a number of priorities in mind. I wanted a space that I had total control over. I wanted the space to be comfortable in all seasons. I wanted it to be quiet and soothing as well as minimalist and efficient. For me, the best creative environment is one where the room recedes and the ideas come forward. To this end, I've resisted over-engineering my space. I have adequate storage, four walls, tall ceilings, and just enough space to shoot a range of projects. Best of all, since I own the prop-

The two biggest obstacles you'll need to overcome are going to be size and ceiling height.

LEFT—*Good floor covering makes your studio safer and more comfortable. These inexpensive interlocking foam tiles from Costco can save a dropped lens from a nasty fate.* ABOVE—*Another good reason to have a padded floor is shown in this image of Piper.*

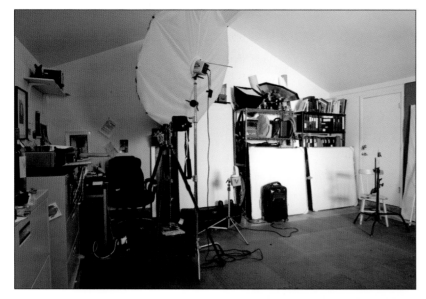

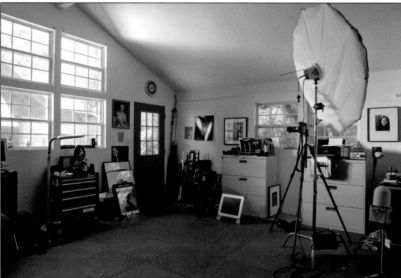

erty I can have all these things rent free. The one thing I added that I now find to be as irreplaceable as my camera and lights is padding for the floor. I used a floor-covering product made out of very cushiony foam that I bought at my local Costco. This not only makes my feet very happy, it has already paid for itself many times over in keeping lenses and flashes from destroying themselves when they (inevitably) hit the floor.

The Garage: The Modern Iteration of the American Workshop. If you live in a house with a two-car garage, you're in luck (really, the car manufacturers went to a lot of trouble to make your car waterproof; it'll keep just fine out on the street or in the driveway). Have a garage sale and get rid of everything—the kids' bikes, the lawnmower, the greasy tools, and the camping gear. Sheet rock the walls, insulate the heck out of everything, and add an air conditioner. All of a sudden you've got a workable space that would cost you a couple thousand bucks a month in New York City. If it's a three-car garage, you're set for life. If it's a four car garage, I'm jealous.

This is all you need if you're doing photography for the joy of it. If you want to start using it as the headquarters for your rapidly expanding photography business, you'll need to check into a few issues. One is zoning, because every town is different and every planned community has its own restrictions. And just as this book isn't a primer on interpersonal relations, it's also not a primer on real estate law—so consider this a disclaimer: Talk to your legal guy before you slap the neon sign on the front of your house.

Garage owners rejoice. Now you have a space where you can shoot a tremendous range of subjects—and all the improvements are a one-time cost. (Just remember to paint those purple walls white. Or gray. Or black. Otherwise, you'll see strange color casts when light bounces onto your subjects.)

No Garage? Try Shoving the Couch Around. If you're living in an apartment, condo, duplex, or house without a garage, your next best choice is to take over the biggest room in your living space that you can reasonably get away with. Sadly, the living room, which is likely the most communal of spaces, comes to mind first. But there it is; if you really want a studio in your home, you'll probably have to go this route. Find a nice, empty closet that you can store everything in and figure out how to best rearrange the furniture. It may not make you popular with your housemates, but sometimes people have to suffer for your art.

A common problem with most residential spaces is ceiling height. If you have standard nine-foot ceilings you might want to consider painting them black. (Run that by your decorator!) Black ceilings keep light from bouncing around and overfilling your images, a problem that reduces contrast and snappiness.

Commercial *vs.* Residential Spaces. Once upon a time, professional photographers specializing in portraiture had to maintain studios in a retail-oriented areas. Mom-and-pop studios thrived in malls and in retail centers near nice neighborhoods. At some point, more and more people started demanding "location portraits" in parks and near areas of natural beauty, and the traditional studio portrait declined in popularity. At the same time, the real estate market drove prices on retail space through the roof across the United States. Finally, manufacturers began to deliver nearly "foolproof" digital cameras. This trifecta of change took its toll, and the traditional studios began to dry up.

This trifecta of change took its toll, and the traditional studios began to dry up.

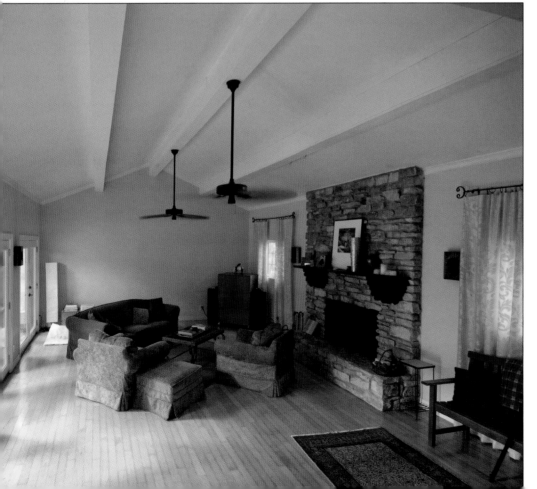

When the 400 square feet of my studio space are not enough, we press the living room of the house into service. It's quick work to move the sofa and chairs onto the screened porch and we end up with more than 650 square feet of temporary studio to work in.

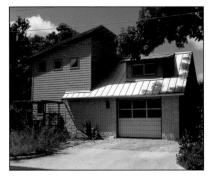

When my photographer friends Frank and Mary Pat got tired of paying an ever-escalating rent for a downtown studio space, they took a good look at their own residential property and decided that a studio was a better use of space than a garage—so they built one from scratch. Note the roll-up door to one side for easy equipment loading. It's even got "curb appeal." No more rent increases to worry about.

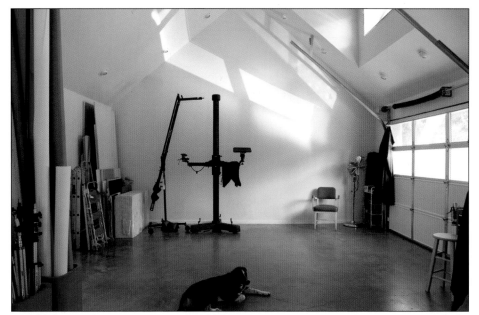

More and more, photographers are maximizing the potential of their own property . . .

While there are still premium studios open for business adjacent to some of the country's priciest residential neighborhoods, the rest of the industry has changed. More and more, photographers are maximizing the potential of their own property by rehabbing an existing garage or utility building or creating a new space on their own residential property. While some neighborhoods have ordinances that don't allow home offices (check with your lawyer), things in many parts of the country are less restricted and photographers are taking advantage of this to create spaces that offer nearly everything needed to launch a business.

Back in 1995, when I moved from a 2500 square foot building near Austin's downtown business district into my current space, I was concerned what clients might think. In the many years that have passed, though, I'm happy to say that not a single client has complained about our studio or its location in a residential neighborhood.

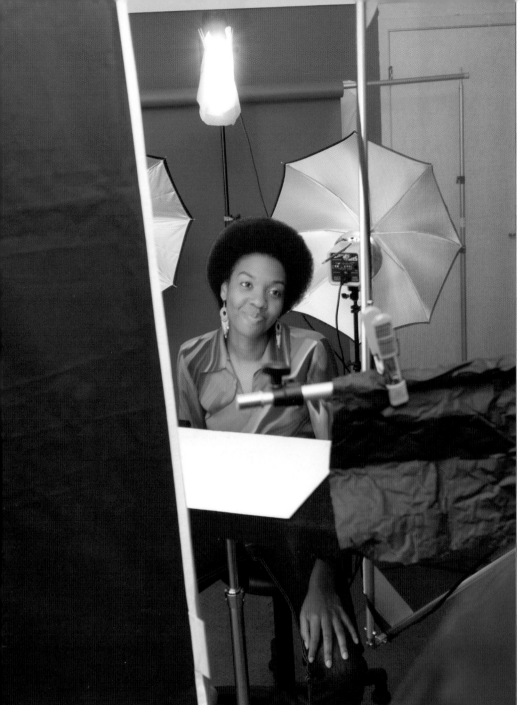

Moving Forward

The studio is all about "making" and not just "taking" a photograph. Out on the street, all you need to do is react to whatever transpires in front of you. The whole point of using a studio is to be able to control every aspect of your photography. In the studio, you decide what background to use, what kind of lights to use, the color and character of the light, and so much more. Of all the decisions you'll make, the most important technical choices will concern the lighting—whether or not to use hard, chiseled light with deep black shadows or soft, effulgent light that wraps around your subject and provides soft transitions between highlights and shadows. This is the subject of the next chapter.

Of all the decisions you'll make, the most important technical choices will concern the lighting . . .

2. Light and Lighting Explained

You need to know what kind of properties light can possess if you want to understand how lighting instruments, modifiers, and accessories work—and how you can control the properties to make your own visual statements.

Color Temperature

Light has different temperatures, and different temperatures mean different colors. What this really means is that light has its own range of colors, from very warm red to very cold blue. The warmness or coolness of the light emitted by a light source can be measured and is expressed as a color temperature, noted in degrees Kelvin (K). Every lighting instrument works in one part of the color range or another.

Different Light Sources, Different Color Temperatures. As humans, we use the direct light of the sun as our standard. Sunlight, when measured between the hours of 10AM and 4PM, measures somewhere in the range of 5,000K to 6,500K. The higher you go above sea level, the higher the temperature and the bluer the light appears to your eyes—and to your film or digital sensor. In high mountains, the light can exceed 10,000K and become quite blue. This is because it contains more ultraviolet energy.

At the other end of the scale, household lights put out more reddish light. A typical household bulb emits light waves that measure around 2,600K. To see how red these lights really are, try leaving your digital camera set on the daylight white balance while shooting in the evening in a room lit only by regular light bulbs. You'll be amazed at how orange and red the scene will be rendered.

It's very useful, when choosing lights, to understand the effects that the various color temperatures have on our photographs. A mismatch between the abilities of your camera's digital sensor and the spectrum of the lighting instrument

LEFT—*This photograph of Amy was made using a daylight white balance on the camera with tungsten lights. The tungsten spectrum is very weak in blue light components, making it a noisy correction even in RAW.* CENTER—*This photograph illustrates the opposite problem: Amy was shot with daylight illumination but with the camera set to tungsten. It's an easier correction in RAW.* RIGHT—*Finally got the color temperature right in this one: daylight shot with daylight.*

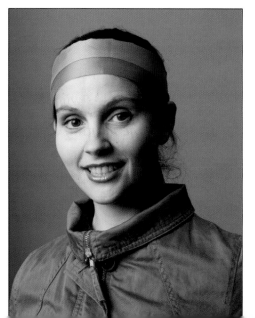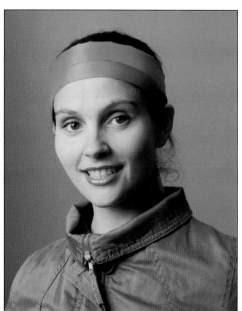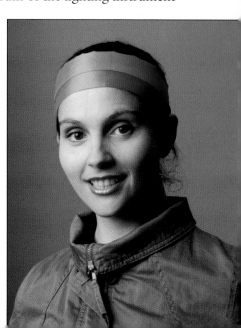

can affect your ability to capture colors accurately. It may also be the culprit in adding noise to your image files.

Here's a quick rundown of the typical lights you'll use in the studio and their color temperatures:

Standard household 60W light bulbs—2,400K

Standard household 100W light bulbs—2,650K

MR-16 "track light" bulbs—2,800-3,000K

Professional quartz-halogen studio bulbs—3,200K

Fluorescent tubes—Use 4,000K as a starting point
(*Note:* These are not continuous light sources and do not have complete, continuous spectrum of light. They spike at different frequencies. As such it's hard to determine an exact color balance for them. You'll need to do a custom white balance for each set of fluorescent tubes you work with.)

Professional electronic flash with UV-coated flash tubes—4,800K

Professional electronic flash with uncoated flash tubes—5,000-5,200K

Hobbyist flash systems with uncoated flash tubes—5,600-5,900K

Good-quality, battery-powered, hot-shoe flashes—5,600-6,500K

Avoid Mixing Light Sources. Try to match all of your lights to the same color temperature. Don't mix lights sources if you want the color in your final images to be accurate and correctable.

Consider this common mistake—one I've made many times. I'll be shooting a person against a white background and use up all of my Profoto strobes lighting the white background. So, I'll decide to use an Alien Bees monolight as my main light on the subject. Unfortunately, the Alien Bees unit is about 400K bluer than the Profoto units. As a result, I'll either have to set my white balance to make the background correct (meaning my subject will be too blue) or to make the subject correct (meaning the background will be too orange/red). There's no white-balance setting that will result in them both being correctly color balanced at the same time using this mismatched lighting. Color differences like these are common between different brands of lights. Even the accessories we place in front of our lights can introduce significant color shifts that are hard to remedy.

A more obvious problem exists when you mix different kinds of lighting in one frame. Imagine lighting with strobe (electronic flash) on one side of a subject's face and then using a tungsten light as a fill light on the other side of the subject's face. The light on one side will be 2,000K or so different from the light on the other side! Balance for the tungsten-light side and the other side of the subject's face will go quite blue. Balance for the daylight side and the other side of your subject's face will become quite orange/red.

Even the accessories we place in front of our lights can introduce significant color shifts . . .

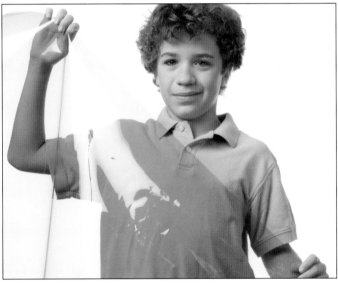

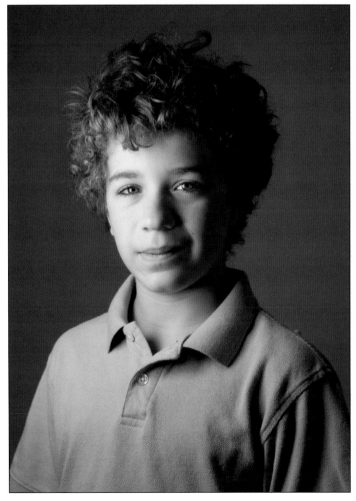

TOP LEFT—*Ben was photographed using our (un)patented, home-made fluorescent light bank. This is what the camera does when set to automatic white balance. Yuck!* **TOP RIGHT**—*Here, we used the same lighting as above, but this time we included a white card and did a click balance in our RAW conversion. The flesh tone is fixed up, but look what happened to the gray background: it's totally blue. The scene can't be automatically corrected to neutral when there are mixed light sources.* **ABOVE**—*Here's Ben with a roll of green correction gel. We put this over our flashes when we shoot in factories or offices that are lit totally with fluorescents. The filter gets us into the ballpark and allows for one universal correction either in the RAW conversion or with corresponding filters on the camera.* **RIGHT**—*Here's a final shot of Ben taken with the fluorescent light bank and the correct color balance.*

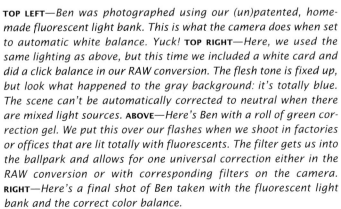

There is a myth that shooting RAW files will allow you to go back and magically balance all of the lighting in your image to the identical color temperature. Nothing could be further from the truth. In every image, there is *one* dominant color temperature. We call it the global color balance. You can shoot in a RAW format all day long, but you can still only choose *one* global color balance when you process your file. If you mix your light sources or your lighting brands, you will have created a postprocessing nightmare for yourself.

So what is a photographer to do? Match the lights, filter the lights, or turn them off—that works with all the lesser sources of light that are causing contamination. If you are shooting in your studio using tungsten-balanced movie lights, the last thing you want to do is compete with a wall of windows allowing sunlight to stream in. If you want to keep shooting with the tungsten lights, you'll need to block off the light coming through the windows.

Here's another example: If you are shooting in a facility that's totally lit by fluorescent lights in the ceiling, you might find that you want/need to engineer a little front lighting to keep human subjects from looking like raccoons. Most of us will reach for a little battery-operated flash. Yet, if we use that flash, we're going to create a color mismatch between acres of overhead lights that may look profoundly green (if your camera is set for daylight white balance). If, on the other hand, you balance the camera to the colors of the fluorescent fixtures, you will probably end up getting a weird pink color cast from anything filled in by your small flash. The solution in this case is to try to match the sources—or at least get the two colors closer together. This is where filters come in very handy. You can buy color-correction filters that will balance the banks of humming fluorescents to your flash (which would be quite expensive in a large area) or you can try to match the color of your flash to the rest of the scene (much easier and cheaper). If both lighting sources share a similar color rendering, you'll be better able to find a workable balance in postproduction.

If you understand color balance, global color balance, and the role of contaminating light sources, you'll be better able to render your images with accurate color or use the mismatched color creatively. Match the colors of all the smaller light sources to the color of your main source and then use your camera's white balance preset to correct each scene.

Use Blue-Channel Compensation to Reduce Noise. The weak spot with most digital camera sensors is their ability to handle the blue component of the light spectrum. The sensors tend to be less sensitive to blue light and so require a higher amplification, or "gain," when images are processed. As the light becomes redder and redder (or warmer and warmer), there is less blue in the total spectrum delivered to the sensor and the camera greatly increases the amplification of the blue channel in order to compensate. This amplification introduces lots of noise, especially when using higher ISO settings. This results in files with lots of noise and grain.

Fortunately, there is a workaround that will help you get much better images when using tungsten light sources. It's something we learned when film was the

If you mix your light sources or your lighting brands, you will have created a postprocessing nightmare for yourself.

only medium: use a blue color-correcting filter over your lens. This might seem like a wild suggestion in the days of automatic white balance, but I've found that putting some degree of correction over the lens when shooting RAW or JPEG files really helps reduce noise in the files. Basically, the blue of the filter replaces the missing blue from the light spectrum, minimizing the need to amplify the blue sensor channel in your digital camera and reducing the amplification of electrical noise that is generally manifested as blotchy grain in your final image. A full correction to record tungsten light as daylight is the 80A filter. An 80B filter is weaker and an 80C filter is weaker still. I find the addition of an 80C is the perfect antidote to any blue-channel noise when I use tungsten-balanced (warm) studio lights with the latest Nikon cameras. Shooting under even warmer lights, like the 60W bulbs in a typical living room, might require a stronger filter, such as an 80A or 80B.

Basically, the blue of the filter replaces the missing blue from the light spectrum . . .

If you are a still-life photographer, this technique will allow you to have the best of both worlds, the fine control of continuous lights and the clean colors that are more usually associated with electronic-flash results.

Direction

A Single Source, A Single Direction. Light has direction. This one seems obvious—after all, light has to come from somewhere. Generally, the light in a scene will come from one dominant direction. Yet, our daily reality seems otherwise, because building interiors are often designed to give a soft wash of light that is diffuse (not sharply focused) and seems to come from all around. Our baseline for understanding lighting is our lifelong relationship with the sun—yet even in di-

rect daylight, the clouds and all the objects around you bounce the dominant light back and forth and all around, lessening the visual effect of a single source coming from a single direction.

In a studio, on the other hand, you get to control the primary direction of light and the amount of light that reflects back into your setups. In many situations, the goal of the photographer is to reproduce light that reminds us of daylight. Consequently, an enormous part of the prevailing, modern style of lighting has to do with using fewer light sources but augmenting them with reflectors.

The Effects of Direction. The direction of light has a great deal to do with our emotional response to a photograph. We use light as a cue to give our images certain emotional context. The obvious example is light that comes from below a subject's face. If you think back to every horror movie you've ever seen, most of the scary scenes are lit from below. Even when kids are telling ghost stories, they grab a flashlight and put it under their chin in an attempt to make the story scarier! From a psychological point of view (or maybe it's an anthropological point of view), "bottom lighting" emulates the light that our ancestors saw for tens of thousands of years each night as they huddled around a communal fire, fearing the dark, the cold, and the legions of predators lurking just outside the circle of light.

Side light emphasizes textures and increases the apparent contrast of an object. Top light emulates the overhead sun and can also exaggerate textures. When we use top light in a studio it tends to make us think of midday sun in its many forms. A hard side light from a sharply focused spot light emulates the last rays of a setting sun on a clear day. Soft, diffuse light mimics the effect of sunlight through clouds. The degree of softness and the degree of fill light correspond to the amount and thickness of cloud cover in a daylight scene.

The direction of light has a great deal to do with our emotional response to a photograph.

LEFT—*The good old flashlight under the chin is the best way to tell ghost stories at a camp-out.* RIGHT—*Not so scary when all the lights are on . . .*

In this portrait of Amy Smith, an 80-inch umbrella was set at my standard "45/45" setup with Amy positioned close enough to the background so that one light did everything. The shot was taken with a Leaf AFi7 medium-format digital camera.

There are few objective measures available for evaluating the value of any one approach to art.

Controlling the direction of your studio lighting can enhance the look of your subjects or ruin your photographs. As an aside, I've found in looking at twenty-five years of work that I am a creature of habit and that I nearly always prefer to light a portrait by starting with the main light to camera left, and nearly always about 45 degrees above my subject and 45 degrees off axis from my camera (I call this my 45/45 setup). I have a theory that this proclivity comes from the way we read in Western societies, from top-left to bottom-right. Lighting a portrait from the opposite side seems disturbing to me. Your approach could be quite different; after all, there are few objective measures available for evaluating the value of any one approach to art.

Soft Light or Hard Light

Light can be hard or soft. This is easy to judge based on the quality of the shadows and the quality of the highlights the light source creates. A soft light source

creates open (light), soft-edged shadows (or shadows with no discernable edges at all) and large, diffuse highlights on subjects. A hard light source creates deeper, darker shadows with well-defined edges and small, sparkly highlights on subjects.

Out in nature, soft light is created when the sun is obscured by clouds or fog. The softest light seems to come from all directions at once, so that the light seems to have no direction at all but wraps around a subject like cotton candy around a paper cone. We know the light is soft when we see no discernible shadow.

One attribute of soft light is its low contrast and its ability to subdue texture on the surface of subjects. Because of this, many photographers love to shoot portraits in this kind of light. Photographing in direct sun (or with hard studio lights) can be much more difficult, because the range of light can easily exceed the capabilities of sensors and film. This leaves us with an unenviable choice: blow out the highlights in order to get detail in the shadows, or live with dense, black, blocky shadows in order to keep detail in the highlights.

In nature, the ultimate soft light would be the totally enveloping light that occurs in thick fog. The ultimate hard light would come from the direct rays of the sun at an angle halfway between top light and the horizon on a clear, dry day at a high altitude. With the right instruments, we can emulate either of these two

LEFT—*This is what hard light looks like in the studio. This image was lit with a portable flash and no fill.* **RIGHT**—*This is what the same setup looks like when you add a small softbox and a foam-core reflector opposite it.*

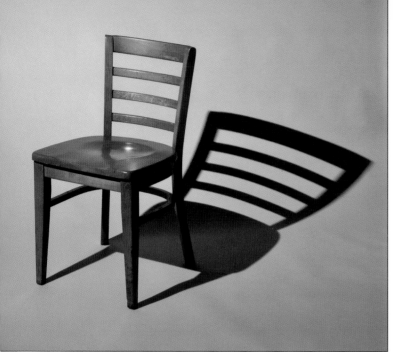 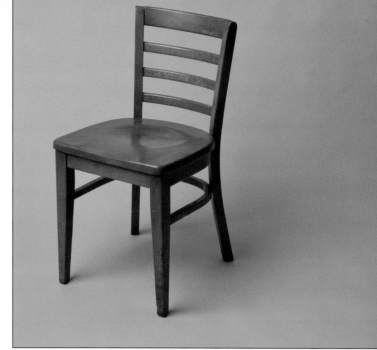

LEFT—*I think it's easier to see the effect of hard vs. soft light with inanimate objects, like my favorite chair. This is hard light.* RIGHT—*This is what soft light looks like.*

extremes in the studio—and just about every characteristic of natural light in between. That's the beauty of studio lighting: total control.

Falloff

Light falls off. ("Falls off what?" you might ask.) Basically, "falloff" is a term used to describe the fact that energy (light, radio waves, sound, etc.) becomes weaker the further you are from its source. How it will diminish can be calculated using a straightforward formula called the inverse square law. Basically, this states that the energy (the amount of light) at a give point is inversely proportional to the square of the distance from the source. What this means is that every time you double the distance between a light source and your subject you cut the amount of light falling on the subject by two stops (*i.e.,* the light on the subject drops to a quarter of its original intensity)!

If you were outside shooting under sunlight, this knowledge wouldn't help you much. The sun is so far away that it's impossible, here on Earth, to adjust our distance from it in any meaningful way. For studio photographers, however, knowing this rule gives us one more tool for controlling light than we would have if we were working outside. As you'll see in the following sections, falloff is an important characteristic of light—and one we can use to great effect in studio lighting.

Falloff is an important characteristic of light— and one we can use to great effect in studio lighting.

Background Control. Suppose you need your background to be much darker than your foreground (for, say, a portrait subject), but you have a limited amount of space and that back wall just isn't going to move back any further. If you move your main light closer to your subject and adjust the exposure so that your subject is correctly exposed you'll find that the background will be darker. Falloff has worked to your advantage. By moving the main light closer to the subject, you have actually increased the relative distances between the main light and subject and the main light and background. The light will be much brighter on your sub-

ject, which you'll compensate for in exposure, but it won't increase nearly as much on the background, which will record as darker.

Portraits. Suppose you want to dramatically light a portrait and want the light to fall off quickly from one side to the other, or from top to bottom in a standing pose. The closer to the light you place the part of the subject you want well lit, the more quickly the light will fall off on all the other parts, letting them go dark. This is a technique that photographic legend Albert Watson uses routinely in his portrait work. I use it when I'm shooting a standing portrait of an executive and I want the light to emphasize his face then fall off quickly as we head toward his feet. I will put a small softbox just over his head and slightly in front of him. If I use it correctly, I will get a perfectly lit face. By the time we get to mid-chest level, the light will be at least a stop lower. When we get to his waist, the light will be at least two stops lower. The visual result is much more dramatic than traditional lighting using a softbox at a distance.

Notice how quickly the light falls off (or gets darker) as we go from Ben's head to his waist.

Multiple Subjects. The downside of the inverse square law rears its ugly head when you are attempting to dramatically side light a group portrait or a still life. You want the light to be directional, but you also want to light each face in the group to have the same exposure value. If the light is too close, people on one side of the group will be too light and people on the other side of the group will be too dark. If you remember the inverse square law, however, you can keep moving your light further from the group. As the distance between the light source and the subjects increases, the light will fall off more slowly and create more even exposure values on the faces. Of course, if you want to maintain the same shooting aperture you will also need to keep increasing the power of the light source as you move it away from your subjects.

Using Reflected Sunlight. Here's a really neat trick I learned from my days as a director of photography in film and video. Using it, you can combine the inverse square law and the technique of "bouncing light" to curtail the falloff of your main light.

When we were shooting a video on the waste streams of nuclear reactors, we needed

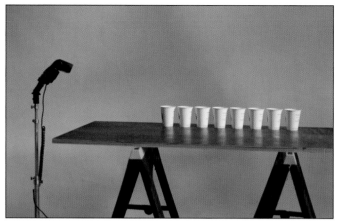

Here's a demonstration of how falloff works in the studio. We set up a series of paper cups and lit them with a flash placed close to the cups.

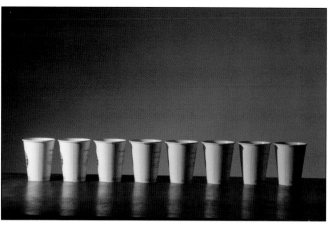

Here's what happens. The light falls off at a rapid rate, just as the inverse square law would predict.

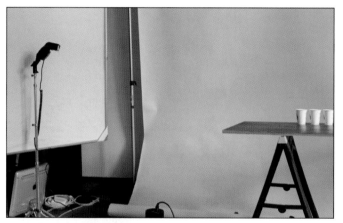

If you move the light back much further from the cups, you will reduce the rate of lighting change across all of the cups.

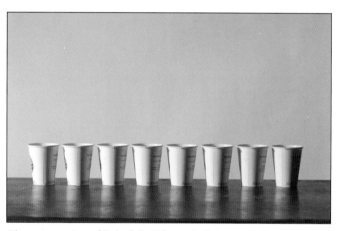

The progression of light falloff from the left cup to the right cup is much less severe than in the first example. You can use this knowledge to get more mileage out of your one-light setups.

You can always make use of "shiny boards" to increase the distance that light travels . . .

to videotape an interview in a building that did not have electrical power. There were no windows in the area where we needed to shoot, and the low level of light would have degraded the image (because of the need to increase the gain on the shooting camera). I watched in amazement as two veteran grips set up a series of "shiny boards" (bright, silver-surfaced reflectors) and bounced the direct sun from one board to the next. The second large board flooded the interior space with bright sunlight. And here's the cool part: since the sun was 93 million miles away from the interior of this storage facility, the falloff from the front of the room to the very back—some sixty feet—was less than half a stop! In effect, the light was perfectly even throughout the space. We were able to film as though we'd spent hours lighting the space.

You probably don't find yourself lighting electrically deprived sub-buildings on the grounds of nuclear power facilities very often, but there are ramifications for the work that we do in the studio—especially if you are dealing with the constraints of limited space. You can always make use of "shiny boards" to increase the distance that light travels in your studio and to decrease the effects of rapid

LEFT—*This portrait was shot using light bounced off a silver panel from outside the studio through a large window. This technique can easily be done with a piece of silver-foil insulation board, found in most building-supply stores.* ABOVE—*We bounced sunlight into the studio using a 48-inch Chimera panel covered with a silverized fabric. (We're reducing our "carbon footprint.") We'll look at this shoot in more detail on pages 60–62.*

falloff. You could also experiment with using sunlight, bounced in through your doors or windows, to give your studio images a different look.

We used "shiny boards" manufactured by a company that specializes in movie equipment, but you can do exactly the same thing with shiny insulation boards from a discount hardware store. The light doesn't care whether or not you spent a lot of money on your reflectors, it just goes where you point it. (More about reflectors in chapter 4.)

In the above photograph, supermodel Heidi was photographed using only sunlight bounced into the studio from a Chimera panel covered with a reflective silver material. A Target shower curtain was used as a soft diffuser and a hunk of white foamcore was placed as a fill card.

So, light falloff has a lot to do with the way your studio photographs look. Understanding and mastering the principles involved gives you more "paint on your palette" as you create images. It's just another variable of the character of light.

Fill in the Blanks

Fill in the blanks—or, rather, I should say fill in the *blacks*. While it's not a characteristic of light, I want to talk about using "fill."

Controlling the Tonal Range. For the most part, our work in the studio involves emulating good lighting that we experience firsthand in the real world. Our eyes have a tremendous ability to see into some of the deepest shadows while also adjusting to fine detail in the brightest areas. It's like automatic HDR (high dynamic range) imaging. This may have to do with the ability of our brains to constantly sample a scene and compile the millisecond by millisecond scans it creates into one consistent vision. Our cameras can't do that; sensors and films display a single frame that is constrained, by the inherent technology, to a given contrast range.

What Gets in the Way

Lighting doesn't exist in a vacuum. In fact it's good to remember that *only* in a vacuum does light act exactly the way physics tells us it will. In the real world, everything between the light source and the subject transforms the look of our final images. Just as atmospheric particulates give us a richer sunset, whatever you place between your lights and your subject will affect the final look of your images. I was reminded this when I shot a stage show for a local theater. They were using fog machines, which made their sharply focused color spot lights look really dramatic to the audience. The end result for the photographer, however, was painfully low contrast and very little detail!

For most of its history, photography has been shared on reflective, printed materials. In the last decade, an increasing amount of our imagery has also been disseminated and shared via rear-lit screens, including those on our cell phones and television sets. Neither option can come close to matching the huge range of colors and light values of the actual scenes they represent—and just to make things even more complicated, each of our media has a *different* range of available values. Printing on glossy paper yields a much wider range of tones, from dark to light, than does printing on matte paper. Most CRTs have a wider range of colors and tones than LCD screens, and LCD screens quite handily beat the image quality of digital projection (which also relies upon the reflectivity and smoothness of the recipient screen).

Our task in lighting, then, is to use our creativity and technical knowledge to translate the "feel" and general quality of existing light into a range and quality that best fits these presentations. Unless we are seeking a very graphic effect, fill light is an important component of this overall lighting design, because it allows us to control the final contrast range (the number of discrete steps between inky black shadows and bright white highlights devoid of detail).

Passive Fill Light. Fill lighting is a bit of a misnomer, though; we *can* use additional light sources to provide fill, but we can also use passive reflectors of different types to do the same thing—and with our knowledge of the inverse square

I'm sure you've guessed by now that this was lit with the biggest softbox I could find (4x6 feet) as close to my camera lens as I could get it. The only fill was many feet away, from the white wall of the studio. A small softbox, placed low, tickles the background.

law, our use of reflectors can be quite nuanced. I tend to depend on flat reflectors much more than on actual light sources. One reason is that they do not add a second shadow to a scene the way an additional light source can. I use white foamcore boards; shiny boards adapted from building materials; store-bought, pop-up reflectors; white bed sheets; the sides of buildings; and anything else that comes to mind to fill in shadows.

In every instance, I am trying to reduce a high-contrast scene to a lower-contrast interpretation. I am trying to allow my audience to see detail in the shadows and in the highlights, whether they are looking at the photograph on a wall or a computer screen. Nearly every photographic example in this book makes use of some kind of fill light.

Practical Example. Here's a demo that shows the compression of contrast range via the modification of the dominant (single) light source and the progressive addition of bounced fill illumination along with the diffusion of the main light.

In this demonstration I want to show three things: first, how important the direction of light is in your setups; second, how the right diffusion and the right reflectors can tame lighting contrast, change the look of the light, and make a product photograph work; third, that you can do a nice tabletop photograph with just a handful of very inexpensive tools. This series of photographs of oranges is an exercise that many photography students have done over the years—and if you haven't done it yourself, you might want to buy a few oranges and try it. It's one thing to "know" the concept, but it really is quite a different thing to "experience" the concept. I think it's a different way to learn. We'll start with an interesting light.

I love going to discount hardware stores, because I always find interesting products and fixtures that make great studio lights or lighting accessories. Take the humble "work light" for instance. These are portable fixtures used in construction and other trades where workers need a bright source of light to work by. For around $50 you can buy a work-light setup with two 500W bulbs in separate enclosures and a dedicated stand. The bulbs are tungsten-balanced halogens and, though the inexpensive reflectors designed into the lights are hardly optimal for photography when used directly, you can easily modify the light with any number of modifiers to create a solid, workable illumination.

On a recent visit to one of the large hardware stores I actually found this lovely work light for the princely sum of $12.95 (USD). For less than the price of three medium-sized lattés from a typical coffeehouse, you can have a 250W lighting fixture with a safety screen, an ultra-violet filter, an extra bulb, and several types of mounting hardware! Absolutely amazing.

I tend to depend on flat reflectors much more than on actual light sources.

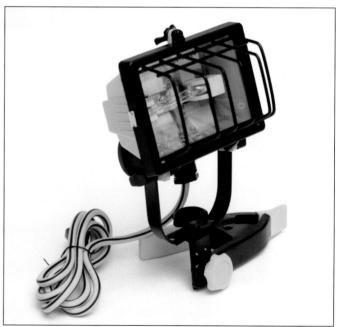

This is the inexpensive ($12.95) 250W tungsten-balanced worklight we'll use for our lighting setup.

I grabbed one from the shelf and put it in my reusable shopping bag along with an assortment of $1.50 "A" clamps and I headed back to the studio to experiment. I thought it would be cool to use less than twenty-five dollars worth of gear to do a series of still-life shots in the studio to show just how little gear is required to make photographs.

So, let's look at the classic photographic lighting exercise ("How many ways can you light an orange?") with just one $12.95 shop light. Our subject is a nice bright navel orange on a contrasting piece of blue paper.

We've set up a work table, rolled out some seamless background paper in a nice shade of blue, and we're ready to get lighting.

Before we get started, here's the orange illuminated by one simple light bounced off the ceiling.

I began by setting up my standard studio work table, a classic construction consisting of two plastic sawhorses topped with a large piece of plywood. First, I set up the worst lighting I can imagine: the raw light fixture placed right next to the camera and pointed directly at the orange with no light modifiers. The image below shows what I get.

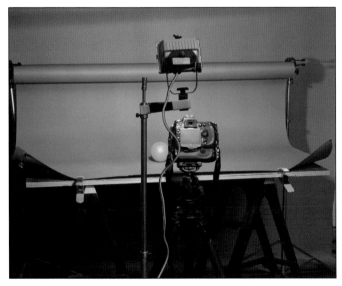

Our main light is positioned right next to our camera and aimed at the orange without modification.

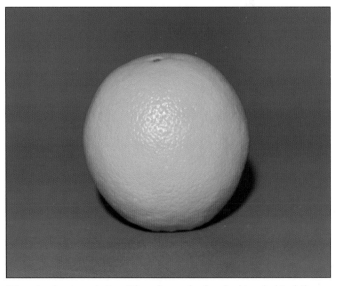

We get a boring photo with a sharp shadow lurking behind the orange—just what we'd expect from a flash bolted onto the camera.

Next, let's try moving the light over to camera left. Now the light is positioned 90 degrees to one side of the camera's line of sight. While the photo "feels" a bit better than the one lit from camera position, the bare light creates a harsh specular highlight on the orange and also shows a harsh, deep shadow on the opposite side of the orange.

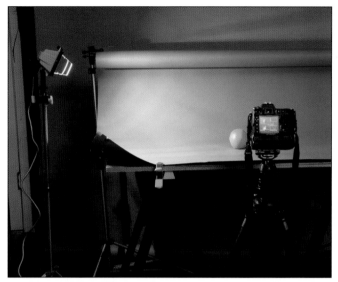

We've moved the light over to the side so that it is 90 degrees away from the camera position.

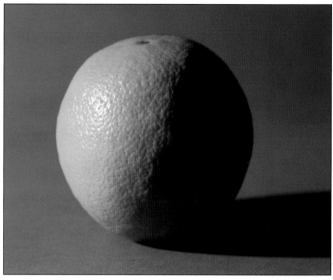

Now the light has some direction and helps with creating an illusion of depth—but it is still unattractive.

Next we'll try the light directly over the top of the orange. Basically, we get the same result, but the image is flatter or less contrasty. This is because some of the light is reflected back onto the orange by the blue paper it is sitting on, which acts as a fill source. The bounced light has taken on the blue color of the paper and pollutes the lovely color of our orange.

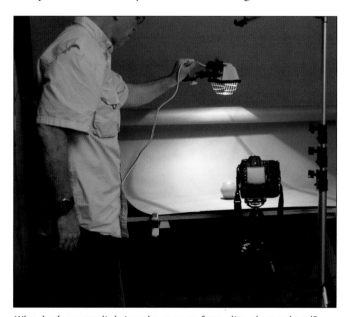

Why don't we try lighting the orange from directly overhead?

This closeup of the top-lit orange shows that it's not much of an improvement.

Finally, in desperation, we'll use our bare light at what I call "45/45." That's raised 45 degrees up from the subject and placed at a 45-degree angle to the camera/subject axis. This is my favorite light position for most portraits, and it usually works well for typical product shots. Again, the unmodified light turns in the performance we expected: hard, specular highlights coupled with a hard, sinister shadow lurking on the opposite side.

Placing the main light at a 45-degree angle to the camera/subject axis works well for portraits . . .

. . . but not as well for oranges.

Now let's build the lighting on this orange as if someone were paying us. I'm going to side light the orange to show off its texture and geometry. We'll place our cheap work light about a four feet to the right of the orange and raise it so that the light is about a foot above the subject position. Below is our beginning shot. It looks just like our first side-lit shot of the exercise.

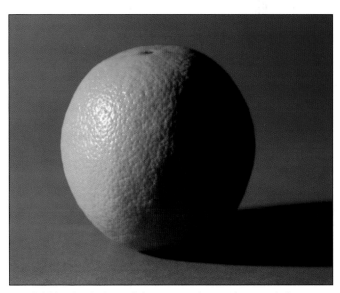

Let's go back to our 90-degree lighting setup.

We did like the feeling of dimension this angle provided, just not the effect of the hard light.

The next step is to add a light modifier to change the basic quality of our single light source. In keeping with the idea of using minimal gear, we'll forego using our pop-up diffusers, Chimera silks, or other pricier modifiers. Instead, we'll create a diffuser by taping a large sheet of tracing paper to an old picture frame. To begin, we'll start with the diffuser a little less than three feet away from the orange.

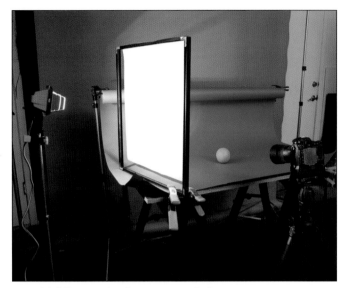

We add diffusion to soften our main light.

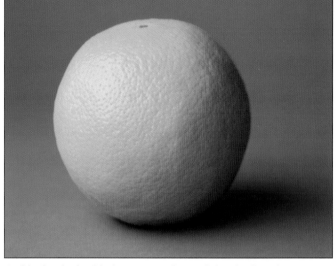

Suddenly, the highlights are gentler and the shadows less scary.

The difference between the modified and the unmodified light is pretty obvious, but we also know that the closer the diffuser is to the subject (all other parameters left unchanged) the softer the light will become. In the next step, we move the diffuser much closer to the orange, taking care to keep the frame—and the inexpensive "A" clamps holding it in place—out of the camera's view. As you can see, the image becomes softer still. The shadow has much softer edges and the highlight area has become much more diffuse. (When we use the phrase

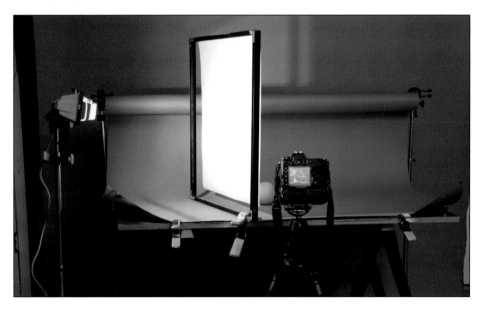

LEFT—*The closer the diffuser, the softer and broader the highlights.* **ABOVE**—*These clamps work for everything. Here we use them to hold up our broken picture frame.*

"more diffuse" it means that the transition from the basic tone of the orange gradates much more gradually and smoothly into the bright area of the highlight reflection. This lowers the highlight reflections, slows the rate of transition between the tones, reduces the overall image contrast [range of tones from light to dark] and, in most cases, renders an image that is more pleasing to the eye.)

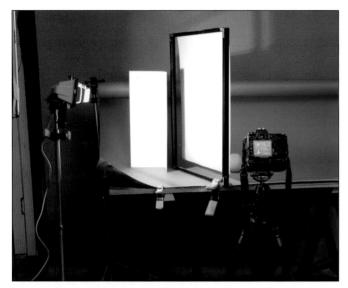

We use pieces of cardboard to block the light sneaking around the edges of the diffusion frame.

The main light is working, but we still need some fill for the other side.

The next step in building our final orange photo is to add a bit of fill to the opposite side of the orange from the main light source. This will fill in the shadows while softening the highlight area even more. We could use a Chimera panel with a white reflector or one of our pop-up reflectors as a fill device, but in keeping with our minimalist theme, let's use a piece of white foamcore board instead.

Let's start by attaching our foamcore to a light stand with one of our handy "A" clamps and placing it a little less than three feet from the orange on the op-

There's a white piece of foam core way over on the right.

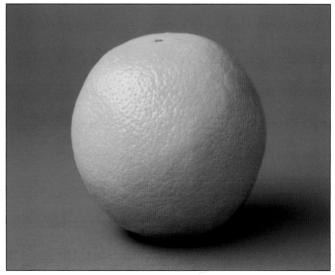

And here's what the fill adds to the orange.

posite side of the orange from our work light. The effect, when compared to the non-filled example, is subtle.

Now, let's move the foamcore in about two and a half feet. As you can see, the shadows get softer and much more open. (When I say the shadows are "open" what I mean is that there is enough light hitting the shadow area so that the camera is able to record texture and detail information rather than featureless black. There is no "absolutely correct" ratio or distance for fill light in this kind of work. The amount of fill is completely subjective, and people's tastes vary widely. I go by the trial-and-error method and try to judge the results not by how they look to my eyes but how they look on the computer screen.)

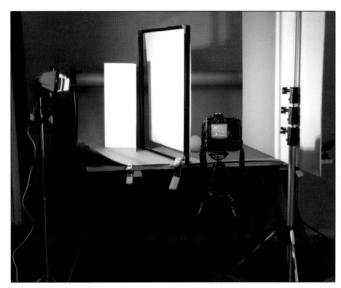 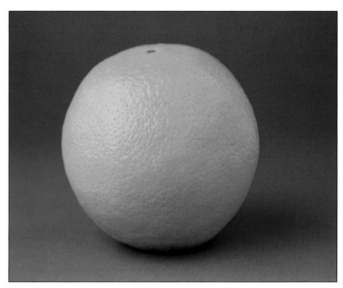

Now the fill card is about two feet from the orange. *And here is what our hero looks like with a bit more fill.*

There is always a trade-off. Our first in this series of shots, using the light without fill or diffusion, yields the highest color saturation and the maximum amount of textural detail. Each successive addition of fill light or main light diffusion reduced the contrast, saturation, and textural rendering in the images.

Now, bear with me, dear reader. Someone, somewhere is reading this book—probably while standing in a book store—and thinking that a piece of foamcore is a "mighty pricey" and "elitist" solution to providing fill light. So let's take the exercise one step further and replace the foamcore fill card with a tacky, white promotional t-shirt that I got for free at a bar. In the final shot (next page), the fill light is courtesy of an unnamed alcohol distributor. (Of course, I've added the t-shirt here as a joke, but I *have* actually used white shirts, on assistants and otherwise, as quick fill modifiers in a number of shots over the years.)

Motivation

Let's talk motivation. I'm not thinking of Anthony Robbins or Norman Vincent Peale, here—I'm thinking about "motivated lighting." In movies, the directors don't want the lighting to steal the scene, so they work closely with the director of photography (or DP) to create lighting that is believable for the story being

Here we swap out the costly piece of foamcore for a free white t-shirt.

The result is a nicely lit orange with a soft highlight, an open shadow, and a feeling of roundness.

You get the picture: the lighting should match the scene you are trying to achieve.

told. If two actors are having a candlelit dinner then the "idea" of a candlelight dinner "motivates" the design of the lighting. The DP strives to make the scene look as though it had been lit by the light of just the candles on the table, even if it is actually lit by a number of movie lights with big reflectors and all the esoteric lighting equipment at their disposal. A scene in an office would be lit as though everything was illuminated by banks of ceiling-mounted fluorescents. In all these situations, the lighting is motivated by what would occur in real life in each situation. Wild hair lighting and glamour-portrait lighting wouldn't be convincing in a photograph meant to convey sadness or meant to mimic the light you might see in a family room. You get the picture: the lighting should match the scene you are trying to achieve. It should relate to the emotion you want to evoke. In a word, it should be "motivated."

3. Yippee! Let's Go Shopping for Stuff!

Now that you understand the various qualities of light, let's move on to the nuts and bolt of lighting: the actual tools you'll use to light the scenes in your photographs.

Battery-Powered Flash

Most of us are familiar with the small, battery-operated electronic flashes that are usually used plugged into the hot shoe on the top of your camera. All flashes operate in pretty much the same way. Whether they use batteries and sit on top of your camera or they plug into the wall and sit on top of sturdy light stands, they all work by drawing electricity, storing it up in capacitors and then, when you push the shutter button, shoving all that electricity through a glass tube with metal points at both ends. The flash is the arc of electricity between those two metal points. That's it. The flash is pretty quick. In the biggest of the studio-style electronic flashes, the action happens in several hundredths of a second. In your battery-powered flash, the duration may be several thousandths of a second.

A flash tube on a studio monolight.

Positive Attributes. Electronic flashes, as an extended family, have a number of very nice attributes. The light is pretty consistent from flash to flash. That means that every time the unit flashes, the color temperature of the light emitted remains the same—as does the power output and the duration. Since the exposing light lasts for a very short amount of time and consists of a relatively balanced spectrum (without a lot of infrared), the flashes don't generate a lot of heat. This makes them very convenient (and safe) when you want to point them into fabric umbrellas or put them into enclosed softboxes.

Another useful quality of electronic flashes is their relative ability to freeze motion. In this regard, smaller units with lower power usually have shorter flash durations which can be very useful in freezing very fast motion. But all electronic flashes have a general ability to freeze most kinds of subject motion.

Finally, battery-operated electronic flashes can be used anywhere you want without having to worry about finding a power source. This category also includes some larger flashes with modern, high-capacity battery packs (see page 53 for more on this).

The majority of studios generally default to using flash because of all the good points listed above. If you want to specialize in studio-style portraits, you could start a budget operation with just a few, inexpensive battery-powered electronic flash units.

Battery-operated flash units can be used just about anywhere and attached to supports with a wide range of "grip" gear. These are just right for adding an accent to a studio photograph.

Kevin Rollins was illuminated by five battery-operated flash units when photographed at Dell's headquarters in Round Rock, TX.

Budget Solutions. The change from film to digital is a real plus if you want to use small-budget resources in order to do big-time images. There's been an intersection of coincidental evolutions in photography. We now have digital cameras that give remarkably clean files at sensitivities of up to 800 ISO. When you shoot at ISO 800 (or 400), you need just a fraction of the light that you would have needed at ISO 100 to achieve the same aperture and shutter-speed settings. That means a small hand-held flash can easily do the same kind of work the old-fashioned studio electronic flashes could do.

We now have a new generation of electronic hot-shoe flashes that can be used at full power or "dialed down" to $\frac{1}{64}$ power or even $\frac{1}{128}$ power. New battery technology means these flashes run longer and recycle more quickly than ever before. Rechargeable nickel metal hydride batteries (NiMH) can be reused for five-hundred high-powered usage cycles and cost not much more than disposable alkaline batteries.

An important part of the shift to smaller electronic flashes is a result of the instant feedback photographers get from their digital cameras. A quick test shot lets you know, in real time, if you need to fine-tune your exposure. You can lighten or darken your image, change your light ratios if need be, and then go on to photograph your assignment with confidence. If you need to use a smaller aperture to extend your depth of field, you can change your camera's ISO setting to compensate.

Drawbacks. In truth, I could do most of the assignments I normally handle with nothing more than three or four small battery-powered flashes. What do I give up when I choose this budget option over my traditional, larger, heavier, studio electronic flashes?

First of all I lose the benefit of modeling lights. These are light bulbs that sit in the same fixture as the flash tubes in studio flashes and give a basic representation of how a scene will look. These modeling lights are different enough from the flash that I don't really depend on them to see exactly how an image will look when the flash goes off—but they are nice to have, because they help illuminate your subjects while you are focusing and composing. The light they give off also

keeps the model's pupils from opening up too wide. In reality, though, good overall lighting in your studio space will easily compensate for these two factors and the use of a digital camera will give you the feedback you need about the actual effects of the flashes.

Another benefit you give up when using the battery-operated units is very fast recycle time. Battery-powered units meant to fit into the hot shoe of your camera tend to use four AA batteries for their power. The electricity from the batteries needs to be stepped up by an electronic circuit and then stored at a higher voltage in the flashes' capacitors until you trigger the flash. This process generates heat, and trying to speed up the process would require heavier and more expensive components in every part of the electronics. Because of this, the average recycle time with fresh batteries is around five to ten seconds at full power. Some small flashes have a receptacle that allows you to bypass the electronic step-up circuitry and directly apply electricity from a high-voltage battery system to the capacitors. This speeds up the recycle time to around one to two seconds. Since the flashes are not fan cooled or designed for heavy-duty operation, however, cycling them too quickly for twenty or thirty exposures can cause overheating and destroy the units.

The other side to the recycle story is that, unless you are shooting fashion sessions, most studio photography can be shot at a reasonable pace. Also, shooting in a small space with efficient flash-modifying accessories means that you'll probably be able to use small flash units at less than their full power. This speeds up recycling times and reduces the possibility of overheating. (For more on this, see page 49.)

Camera Compatibility. There are a wide variety of shoe-mount, battery-powered flashes on the market, but if you already own one of the advanced-amateur or professional digital cameras, you'll probably be best off buying flash units designed to work synergistically with your camera. Many manufacturers have also introduced units that can be controlled wirelessly from your camera position and have plenty of features that make their purchase price justifiable. I shoot with Nikon, so my choice was to buy one of the flagship models, the SB-800 AF Speedlight, as well as three of the SB-800's younger siblings, the SB-600 AF Speedlight. I usually use them with Nikon's SU-800 controller, which acts as a trigger and controller. I almost always use them in their manual, power-ratio modes, because the light remains constant and doesn't depend on the camera's sensor being aimed at a specific area to ensure proper exposure.

Canon users will find all the same power, flexibility, and control in the EX series of flashes. The Speedlite 580EX II is the current top-of-the-line flash and matches the Nikon SB-800 almost feature for feature. Similar, fully configured flash systems are available from Sony, Pentax, and Olympus—and they are very practical for a budget studio setup. This is especially true if you also want to use them as they were designed, for weddings and other events.

For dedicated studio work the only requirements for a good, battery-operated flash are that: the flash can be used in manual; that it can be ratioed (the power

Another benefit you give up when using the battery-operated units is very fast recycle time.

Here's a typical battery-operated flash. This unit is dedicated for use with Canon cameras.

turned down to lower manual settings [½, ¼, and so on]); and that it can be attached to a triggering mechanism such as a radio slave, an optical slave, or a good old-fashioned sync cord.

With a well-chosen collection of three battery-operated flash units and a means of triggering them, you will find that you have a tremendous amount of creative lighting capability at your disposal.

Batteries. These units are uniformly power hungry, but just because the flashes you've chosen were designed to run using four AA batteries doesn't mean your energy choices are limited. If you use your portable flash every once in a while and generally find yourself using power settings around ¼ power, you will probably do best with regular, disposable alkaline batteries. I buy them in bulk from Costco, because they have a long shelf life and I never know when I will want to grab a handful of flashes and a baggie full of batteries as I rush out the door for a quick assignment.

This is a ready supply of energy that doesn't leak energy quickly over time.

If you are more organized and forward thinking than I am, you're probably a good candidate for the current generation of NiMH (nickel metal hydride) batteries, which generally have two to three times the capacity of alkalines. You'll want a couple of sets for each flash you plan to use, so that during a long photo session you can always have one set on the charger as a backup. Remember not to mix battery types, to use groups of batteries from the same manufacturing batch when possible, and to avoid using rapid chargers (these create internal heat and shorten the overall life of the battery). If you do all this, you'll get great performance. The one downside with NiMHs is that they self-discharge while they are being stored. I generally charge mine the night before a shoot, but I've occasionally forgotten and grabbed some batteries that were last charged a month before—only to have them die very quickly.

By the time you have outfitted your portable flash with a powerful external battery you've spent more than you would on an A/C powered studio light.

Many photographers swear by external battery packs for quick recycling and thousands of flashes per charge. Still, I've decided that the portability of the NiMHs outweighs any performance issues—external battery packs are a real pain to carry around all day and inevitably get in the way. Besides, if you spend the money on battery packs for multiple flashes, you might be better off with a different solution altogether: A/C-powered flash.

A/C-Powered Flash
When you tally up the cost of top-quality portable flash units, batteries, chargers, and possibly outboard battery packs, you'll find that you have probably crossed the line—pricewise—into the realm of inexpensive, A/C-powered, studio electronic flash equipment. These can be good, solid workhorses for a small or beginning studio.

Positive Attributes. While you lose portability when you go to an A/C system, nearly all of these systems offer the other benefits you lack with battery-operated hot-shoe strobes. The systems generally include modeling lights, fast recycling, and solid, reliable performance. A few years ago, I bought into the Alien Bees monolights, designed and produced by Paul C. Buff. Their smallest of-

fering is the B400. It has roughly twice the power of the top Nikon or Canon battery-operated flagship units at 160Ws. It recycles in one second at full power and can continue to do so for a good while, as all of the electronics are fan cooled. Every unit contains a built-in optical slave that will trigger the unit when it sees the flash of another unit. Each model also includes a slider control to step-lessly turn the flash power up or down from full power to ¹/₃₂ power. The product line also includes units that range all the way up to 640Ws of power. This translate into two full stops more intensity.

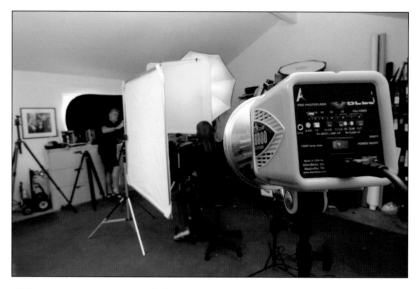

The Alien Bees B800 in the studio.

There are basically two types of systems: solid, no-nonsense monolights or basic pack-and-head systems. There are advantages and limitations with each type, so your choice will be a personal one based on how you plan to use your lights.

Monolight Systems. Monolights are so called because each unit is a totally self-contained lighting unit that can be used by itself or in combination with other units. The package includes a "plug in the wall" flash generator, flash tube, and electronics all in one portable package.

The self-contained nature of the monolight is an asset if you need to place the units far away from each other for a specific lighting effect. All you need is a convenient wall socket for power and the ability to trigger the lights from your camera position. With a pack-and-head system (these are covered in more detail on pages 52–53), you'll always need to be tethered to the power pack—and running additional cables is frightfully expensive and electrically inefficient! Any additional extension between the pack and head also reduces your power.

Among the fringe benefits of using monolights, such as the Alien Bees, over battery-operated hot-shoe flashes, are the included adapters for mounting the units on light stands and integrated clamps that make it easy to attach common light modifiers, like umbrellas. Most monolights and pack-and-head systems also feature optional metal rings that allow you to easily attach softboxes and other accessories.

The basic system for most budget-conscious studios would be two low-powered monolights with a range of reflectors, modifiers, and accessories. This would enable you to do good two-light setups. A typical portrait setup would involve one main light with some kind of modifier, a reflector as a fill light, and a second monolight for the background. Adding a third light to the arsenal allows you to evenly light the background (using two lights on it instead of one), or to stick with one light on the background and use the third light as an accent or hair light.

While I am writing this, the current prices for the three Alien Bees monolight models range from $225 to $360. For most small studio lighting needs, you

Running additional cables is frightfully expensive and electrically inefficient!

could stop right here. Three of the middle priced units, complete with 7-inch reflectors, will run you about $850 total. So, if basic units like this include decent power, variable power control, fast recycling, modeling lights, and fan cooling, what does more money get you?

I have a set of Profoto monolights and the following are what I know to be the differences. First, Profoto has a premium line of reflectors, softlights, grids, and other accessories. The way they are designed allows you to focus or de-focus the lights, fine-tuning the spread of the light for your lighting application. Don't underestimate the creative power that great lighting accessories can provide, but be aware that talent and improvisation can work equally well. The second difference is that the build quality is much higher (conversely, this also makes them a bit bigger and a lot heavier). Third, on the Profoto units, you can use higher powered modeling lights, including 250W tungsten halogen bulbs. Fourth, and finally, the Profoto lights feature a sleek design and say "Profoto" on the side . . . which seems a bit more elegant and professional than a bright yellow monolight with a cartoonish bee on the back. Profoto lights are highly regarded and their power-pack systems are the number-one rental units for high-end photography around the world.

Are they worth two and a half or three times the cost of the Alien Bees units? If you just compare the units based on the light output, I would say no. If you have lots of snobby, brand-conscious, advertising-agency art directors as clients, I would say maybe. If you shoot high-fashion or other applications that call for fast recycling, long-use cycles, and consistent exposures, I would say yes. In the

Profoto lights are highly regarded and their power-pack systems are the number-one rental units . . .

Sometimes, I think the differences between similar powered flashes doesn't amount to a hill of beans. Other times, I find one feature or control that I can't live without—like the 1/64 flash power setting on a battery-powered flash.

end, it is a calculus of moving targets. You have to weigh your budget and figure out where your comfort level is. For those who don't feel as though they can afford the Profoto lights, I offer the very real comfort that, light for light, there isn't anything I can do with the Profoto lights that I couldn't do with the Alien Bees flashes in 90 percent of my projects.

I should note that there are plenty of other choices of monolights on the market, as well. At the lower end of the expense scale, joining the Alien Bees, are offerings from Norman, Photoflex, Flashpoint, JTL, Interfit, and Photogenic. In the middle price ranges are offerings from Elinchrome, Bowens, Calumet, and Dyna Light. We've talked about Profoto, but if money is no object you'll surely want to consider some of the offerings from Swiss lighting manufacturer Broncolor. Their units are the Rolls Royces of the lighting world.

My take? If you spend all your time in the studio it makes a lot of sense to buy a set of monolights and take advantage of their many features. (As luck would have it, most of the popular inexpensive systems are monolights. This allows you to start with one or two small lights and then build up incrementally to larger lights or more involved systems.) If you do a fair amount of weddings, corporate events, or fast-moving journalism along with your studio work, you'll probably want to opt for a combination of monolights and hot-shoe units. I often lighten my travel kit by substituting the smaller, lighter Nikon SB-800 flash unit for a third monolight unit, which I use mostly as a background light at lower power settings.

Pack-and-Head Systems. Before monolights, all the studio electronic flashes were designed around boxes referred to as power packs. These take in A/C voltage and convert it for use with multiple flash heads, which are tethered to the power generator box.

One benefit of pack-and-head systems is the cost efficiency of using one set of circuits, transformers, and the like to power two or more flash heads. Another benefit is that the heads weigh much less than comparably powered monolights. This makes them much more stable when placed at the top of tall light stands. On the flip side, any failure of the power pack renders the whole system useless. (If you have three monolights and one fails, though, you will still have two to complete your assignment; this adds a redundancy working photographers appreciate.)

You can probably tell that my preferences lean toward monolights, but some studio photographers I know swear by pack-and-head systems. For those who do, the range of available models starts at a higher price point than the base level of monolights and escalates up through astronomical to downright whimsical.

Traditional pack-and-head systems can be cumbersome if you want to position two heads far apart from each other. This is the Profoto Acute B battery-powered system, which is great if you only need one head on location.

The current budget champ is probably U.S.-based Novatron, with basic systems starting around the $599 for around 300Ws of total power and two cord-tethered flash heads.

Ultimately, the real reason to use a pack-and-head system is because sheer, brutal, unbelievable power is necessary in your highly profitable, professional, day-to-day shooting. If you are at the level in your photography where you need fast recycling at 4800Ws with incredibly tight control, guaranteeing that every exposure is within a tenth of a stop of every other exposure, you surely know what's out there and where to get it. Studio lights at this level, from suppliers like Profoto and Broncolor, start around $6,000 for a pack and head and go up from there. Photographers using these systems generally dedicate a pack for each head for greater flexibility and redundancy. You'll likely find systems like this only in major metropolitan areas and in the equipment inventory of top fashion practitioners, car shooters, and high-end furniture catalogers.

If you want to light with flash, my recommendation is to start small and work with what you have until you thoroughly understand the limitations of your lights. Then you'll know what you need when you upgrade. The good news is that lights don't continually evolve at the speed of digital camera models (after all, light is light) and basic ones retain their value fairly well over the years. If you start today with a few inexpensive Alien Bees units and decide to upgrade several years down the road, you will very likely be able to sell them without losing much money. Try that with a three-year-old digital camera!

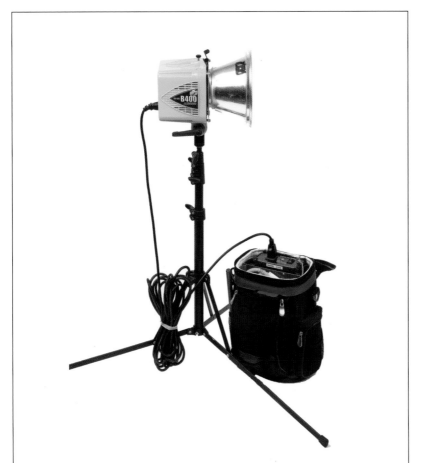

There are a number of battery packs with built-in inverters. This is the first generation of such packs from Alien Bees. The product name is the Vagabond. It's shown here with one of their Alien Bees electronic flash units.

A Battery Packs for A/C Strobes. A while ago, I bought a Vagabond (version 2) from the Paul C. Buff Company—the same people who make the Alien Bees and White Lightning electronic flash equipment. The Vagabond is a well-thought-out product that marries a stout motorcycle battery with a pure sine-wave inverter. It is essentially sixteen pounds of portable power that will run A/C appliances like studio flashes. When I bought it, my intention was to power flash units at locations that lacked wall plugs. I've also gotten a lot of usage in the great outdoors. The best use I got, though, happened more recently.

I'd made an appointment to photograph a local celebrity for a special feature, and the photographs needed to be delivered on the same day. I was also using this photo shoot to try a new technique on a medium-format

digital camera that I had been sent to try out and review (naturally, the review I needed to write also had a short deadline). Since the shoot was scheduled for early in the morning, I took the time to set everything up and test it the night before. I was using the 80-inch Lastolite umbrella with a Profoto head and a 600Ws power pack. I had the Leaf AFi camera set up on a tripod, and I'd already run exposure tests by the time I turned off the studio lights and went home to bed.

Several hours past midnight, though, the winds began to pick up. The noise of branches slapping against the house was bad, but the crash of one-inch-diameter hail that followed was even worse. The lightning was striking so often it reminded me of a strobe light—and a few minutes after the last hail assault, all the power in the house went down. And it stayed down. Our neighborhood wouldn't have power again until after 6:00PM.

Of course, my client didn't know any of this and dutifully showed up right at the appointed time. Time was tight, so we headed to the studio and hooked the Vagabond unit up to the Profoto power pack. With the flick of a switch, there was light! We shot eighty frames with the big camera and encountered not a single hitch or hiccup. With the shoot finished and the client gone, I unplugged the strobes from the Vagabond and got to work on the files with my laptop. The lap-

LEFT—*Shooting black reflective objects is an exercise in using black panels and pieces of felt to keep reflections off the surfaces. This image was created with two 1000W tungsten fixtures placed to either side of the set and directed through large diffusers. This was a long exposure at ISO 12 with a Kodak SLR/n camera.* RIGHT—*This image was lit in the same fashion. We used the Kodak camera for these still-life shots, because it can be set at 6 to 25 ISO for very long, very clean exposures with maximum detail. It's a very specialized studio camera.*

■ **More on Still-Life Photography**

Even in DSLR-type digital cameras, one manufacturer took still-life photography into consideration. The Kodak DCS SLR/n had a complete long-exposure menu that enabled still-life shooters to work at ISO 6 and use exposures up to one full minute. While the camera was a mediocre performer at regular ISOs, it was phenomenally capable at ISOs in the 6 to 50 range—and it could only achieve low ISO images with continuous light! For still life images, using tungsten means you get to pick the exact aperture you want/need and then easily adjust the shutter speed to give you the right exposure.

This reflector is nothing special, but you could do a lot of still life work with one of these and a 250W or 500W bulb.

top had been used a lot the day before and someone forgot to charge it (mea culpa). Fortunately, the Vagabond came to the rescue again, powering up and recharging my computer. It kept going until well after I finished the files.

At that point, I needed to find a way to upload my selected files, so I let the computer suck up a Vagabond inverter charge for another twenty minutes, then drove off to find a local Starbuck's coffee shop with the lights still on. After a quick espresso and a half an hour of uploading, another project was successfully completed. We never missed a step. Now I keep the Vagabond on the charger just in case! It's good to have a backup system.

Tungsten Lighting

We've concentrated on various flash systems for good reasons: they pack a lot of power for the price, freeze most subject movement, are in the same color-temperature ballpark as most daylight scenes, and use relatively little electricity (making them a fairly eco-friendly choice).

Still, nothing says "constancy" like a nice tungsten light. Indeed, a number of still-life and even portrait photographers enjoy working with continuous tungsten light for a number of reasons. Jewelry and product still-life shooters, who routinely use large-format cameras (digital or film), have different requirements than photographers who use SLR-style, cropped-frame digital cameras.

Still-Life Photography. While portrait photographers are generally happy using fairly wide apertures of f/5.6 and f/8, still-life guys sometimes need apertures in the f/16 to f/45 range in order to keep every part of their intended subject in razor-sharp focus. They might also use lots of light-absorbing modifiers in front of their lights. Finally, they seem to like working with very slow ISOs, like 50 and 100. This combination of settings and lighting, when done well, gives them grainless files with layers and layers of detail, all rendered with the highest sharpness possible. (Not a flattering way to photograph a bride or model!)

These parameters require gobs and gobs of juicy light, but it's important to remember that still-life subjects are not moving or breathing. As a result, long exposures can be used in order to facilitate tiny aperture settings. Still-life pros think nothing of using 30- to 60-second exposures in the pursuit of their art. Using flash to capture the same images at the same settings might require several of the aforementioned $6000+ flash systems.

Cost and Power. Some studio guys love to use tungsten lighting. With a long enough exposure time, a tungsten light's cumulative power can easily equal that of the priciest flash units. A 1000W movie light, diffused by a white scrim, might easily give you f/45 at 15 seconds with an ISO of 25—and you would be able to buy a light with this capability for as little as $50. It's true. Most of the "do it yourself" discount hardware stores sell "work light" kits with two 500W tungsten halogen lights, a stand, and the bulbs for around $50. It's one of the true bargains in photography.

When shopping for "A" clamps, I even found a 250W tungsten-halogen fixture that comes with an extra bulb, a clamp-mounting system, and a UV front fil-

ter for the total price of $12.95! Two of these would allow a thrifty still-life photographer to light a wide variety of subjects with good control. Add a translucent shower curtain from Target (for diffusion) and you've got some really nice lighting for less than $40. I was so amazed that I bought one to test. Now I need to go back and get a few more!

Fashion and Portrait Photography. But wait, still-life photography is not the only field that makes use of continuous lights. Fashion photographers often turn to tungsten when the style they are attempting calls for softer results and smoother skin tones. The longer exposures needed for continuous-light exposures help to blend and soften images by incorporating small amounts of subject movement. This is the opposite of the clinically revealing nature of electronic flash.

This is the opposite of the clinically revealing nature of electronic flash.

I like to use tungsten lights when I want to shoot with a medium-length lens at its widest (most open) aperture in order to get a very tiny sliver of focus. One of my favorite portrait lighting styles is to use the biggest diffuser in my studio (74 inches by 74 inches) and shine a 1000W tungsten light, with a very broad light beam, through the diffuser onto the subject. Sometimes I'll even incorporate a second layer of diffusion just to soften the light even more. I generally end up with a camera exposure of around $\frac{1}{30}$ second at f/5.6. I add a blue color-correction filter to the front of the lens, which eats up another two stops of exposure, leaving me with a setting of f/4 at $\frac{1}{15}$ second. I always practice this style of photography with a sturdy tripod and a patient model; it's not recommended for small, speedy children—unless they are asleep.

Equipment. Tungsten fixtures designed for movie production use lamps that are different from everyday light bulbs you find around your house. They use a bulb (envelope) system whereby a halogen gas keeps residue, created by the filament as it glows, off the interior of the glass envelope and redeposits it back onto the filament. Unlike conventional bulbs, the professional lamps do not darken or change color temperature as they age. Depending on the wattage and design of the bulb, they can last for well over a thousand hours before failure.

One of the most compelling reasons to use tungsten lights is the the incredible range of lighting instruments that are available and the degree to which they can be tuned, modified, and utilized for the task at hand. I have a motley collection of these "hot lights" (vernacular of the industry) that range from powerful 1000W floodlights to focusable Profoto ProTungsten fixtures that look like the flash heads from the same company (and which can be used with the same accessories). I also keep a few fresnel spot lights around, because being able to focus them into a tight beam of coherent light can really come in handy. Over the years, I've been able to add to my collection of hot lights by contacting film-industry rental houses and letting them know I'd be interested in buying lights that they may be taking out of service because they are banged up or have been replaced by newer models.

Hot lights are very mature products, having been used and evolved by both the film and television industries for over a hundred years. They are typically

Concentric glass rings in this spotlight help to focus the light into a tight beam when you want one—but the edges of the beam always yield a nice, soft edge. This is a much better choice for most images than a snoot.

The Profoto ProTungstens represent a new category in "hot lights," because they have built-in cooling fans. Most hot lights are essentially movie or television lights that can't use fan cooling, because the productions have to also record very clean audio. In still photography, though, we aren't concerned by fan noise and it's great to have a bit of cooling for a fixture that will be used in a softbox or other confined space. Lights that run cooler increase the life-span of the accessories they are used with while also extending the life of the bulb.

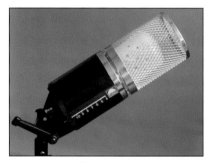

These are really great 1000W tungsten lights with built-in fans. The fan noise makes 'em lousy for video work (where they need to record clean sound) but great for still photography.

Actor Joe York was photographed in his role as Stanley in Zachary Scott Theater's production of A Streetcar Named Desire. *Tungsten lights were used just for a change of pace. There is one fresnel spotlight on the mottled grey background, one 1000W fixture diffused by a 6x6-foot diffusion screen to the left of the camera, and one small 100W fresnel spotlight coming in from the back as a glancing backlight (see page 88 for more on this).*

rugged to the point of indestructibility, engineered for daily, high-duty use, and fairly inexpensive. The downside of hot lights is that using them requires fairly long exposures. This makes them less flexible for lighting people. They also generate a tremendous amount of heat, which makes them a bit uncomfortable to work around. Used on a food set, hot lights would be a catastrophe; they would quickly melt, desiccate, and cook all the products set before them.

For the photographer on a very strict budget, and willing to work within the creative constraints, hot lights can be an initially economical option for a photographer. However, they are not the most eco-friendly option; what you save in the initial purchase price may well be negated in the increased energy use and air-conditioning expenses, depending upon where you live.

Safety. These bulbs put off a tremendous amount of infrared energy and quickly heat up the lamp housing and any metal attachments, such as barndoors. You'll want to get a pair of "set gloves" or heavy leather gloves to use when you need to touch the lamp housing or any of the accessories. Also, you should never touch a tungsten halogen bulb with your fingers. If you do, you might transfer some of the natural oils from your fingers to the exterior of the bulb. This will insulate the glass at the touched area and raise the temperature of the glass envelope in an erratic manner. The temperature differential across the glass may cause it to shatter in a particularly spectacular way. Always handle bulbs, even when cool, with a piece of paper or tissue. If you've accidentally touched a bulb with your naked finger, clean the bulb with alcohol before you attempt to use it.

This shot of Kara is a one-light shot made with a small, inexpensive tungsten fixture. I put a correction filter for daylight over the light to match the color of the daylight coming through a door in the background and added a foamcore reflector to the opposite side of the light.

Practical Example. If you are just flat-out strapped for cash, take heart. I decided to see what I could do with the cheapest lights I could find: the cheesy metal clamp lights you can find at any well-stocked hardware store for around $5 each. The resulting image is shown above (see the caption for details on the lighting setup). So grab a couple of bright household lights and get started!

Fluorescent Lighting

Every time I use my tungsten lights, I find myself wishing someone would make a light that was continuous but never heated up. I would also like these mythical lights to be available with either daylight or tungsten color balances—and it would be great if they were really energy efficient. Finally, I would love it if they gave off a relatively big, soft light. Ta-da! They actually exist. They are called fluorescent lights, and you can get them inexpensively at most building-supply stores.

Balancing with Ceiling-Mounted Lights. Unfortunately, the one thing they lack is impressive output—but that can sometimes work to your advantage. Many years ago, I needed to photograph a businessman in a techy environment that was really big and lit entirely by ceiling-mounted fluorescents. I thought about using available light, but all the light came from the direction of the ceiling and make nasty shadows under my subject's eyebrows and nose. The protocol of the day (pre-digital) was to bring in the big electronic strobes, try to filter the strobes

■ Taking it to Extremes

I have one particularly inventive friend who even refuses to buy light stands. He makes his own studio stands by finding one-gallon paint cans, sticking various lengths of 1x2-inch sticks (or 1-inch PVC piping) into the cans, and filling them up with cement. He's made a number of these, with sticks ranging from two feet to eight feet in length, and he clamps the lights to the poles at whatever height is appropriate. He brags that his cost for each stand device is around $2—and each comes fully equipped with its own version of a sand bag: the gallon of concrete in the can. This same guy makes his diffusers by building cheap wooden frames and stapling tracing paper (or some other translucent material) to them. He's worked this way for years, and while a tony art director from a big ad agency might not "get" his minimalist esthetic, I continually salute him because he is right about one thing: the subject doesn't care where the photons come from. Also, I have a sneaking suspicion that more of his income goes into the bank than mine. (Of course, I'm also pretty sure that taking those cans of cement on location can be, well . . . less than optimum!)

This is a product made by Westcott that uses daylight-balanced fluorescents, a cool alternative to hot lights. If you're on a budget you can always make your own.

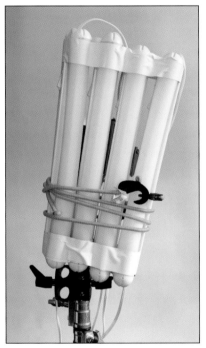

This is my gaffer's-tape and bungy-cord solution to creating a fluorescent light bank. These tubes are "balanced" for tungsten, but that's hardly accurate. I would say they are balanced for green ick.

so that their color temperature was close to that of the existing (fluorescent) lights, and then try to match the power output of the flashes to the general ambient exposure for the giant room. As I recall, when all the filters were applied, we were trying to keep our shutter speed above ¼ second while maintaining an aperture of around f/8. This was all predicated on using an ISO 100 color transparency film. In reality, the background never had the right balance and the whole thing was a visual mess.

I kept coming back to the idea of shooting available light, but I really wanted the main light to be slightly stronger than the down light from the ceiling-mounted fluorescents. I finally decided to go to a hardware store and buy several under-the-counter fluorescent light kits, which—luckily—were a close match to the tubes at the location. I taped three or four of the units together and devised my own weird fluorescent softbox. I had only to find the sweet spot in which to place my duct-taped wonders and I was able to get some nice modeling across my subject's face with none of the effort and disappointment that I had suffered using older techniques.

Equipment. Presently, fluorescent lights are a highly developed and cost-effective lighting solution for small studios—provided you don't need to freeze motion. Since constructing the homemade unit described above, I bought a unit from Westcott (the Spiderlight TD-5) that uses a group of five compact fluorescents. The unit is set up to allow the use of a conventional softbox. It's a wonderful solution for shooting small objects at close ranges, because you can set up your camera right next to the fluorescent softbox, which you can set up inches from the subject without any worry about the heat.

As in any other category of photographic equipment, your choices range from ultra-cheap, make-it-yourself fixture/housing combinations to multi-thousand dollar units created for the production studios of major television networks. What does more money buy you? Well, for one, you won't need to tape a bunch of fixtures together with gaffer's tape. Professional models also have professional attachment hardware, and the interior of the lights will be a very efficient, polished metal. Additionally, the tubes will use advanced circuitry that prevents them from flickering. I'd love to have a set, but I'd also like to have a different camera for every day of the week—and I don't think that's going to happen either.

Free Light!

The final choice to discuss is the free choice. In the early days of both movie-making and photography, natural-light studios were widely used. In fact, movie production moved from New York City to southern California early in the last century mostly to take advantage of the ample, and reliable, free sunlight. Even now, many rental studios in major cities boast about their large banks of north-facing windows and bill themselves as great "available-light studios."

The advantage of building a studio with windows that face north is that there is no direct light through the windows, instead there is a continuous supply of soft light that can be quite flattering for portraiture and some kinds of product pho-

tography. The natural-light studio forces one to become proficient in the use of reflectors and little mirrors to modify light—and it's pretty much useless once the sun sets. Still, the natural-light studio might just be the ultimate green solution for a "low impact" working space.

A European photo magazine, called *Photo Technic*, ran an article back in the 1990s about a very-well- thought-of portrait photographer who only used the "northern light that cascades through my thirty-foot-high bank of windows." He also photographed exclusively with 4x5- and 8x10-inch Polaroid instant film. I suppose it can be done, but my clients expect things to happen two ways: repeatably and on schedule.

Practical Example. My assistant, Amy, and I were doing portraits of Heidi and I thought it would the perfect opportunity to see what we could do with the sunlight bouncing around outside on a 100°F day in Texas.

It was around eleven o'clock in the morning, and the light from the sun was still angled away from the big bank of windows on the west side of my little stu-

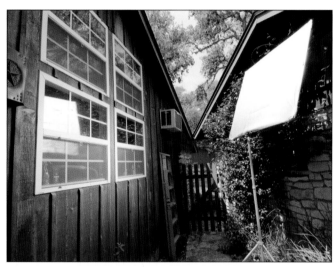

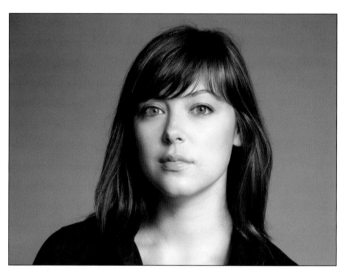

The studio window faces west and we wanted to used 11:00AM sun that was high but still to the east. Up goes the Chimera light frame with silvered fabric.

The raw light streaming through the window illuminates Heidi with a sharp, crisp light.

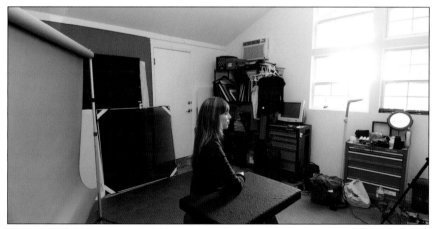

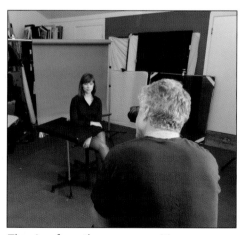

Shot from Heidi's right side showing the light through the window and the blue paper set up behind her.

The view from the camera position.

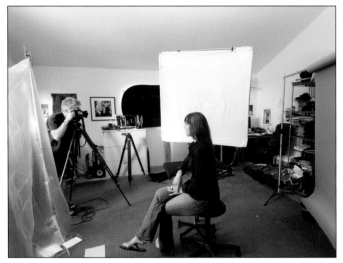

View from Heidi's left side, showing the addition of a fill card and the shower curtain to slightly diffuse the direct sunlight from the bounce board.

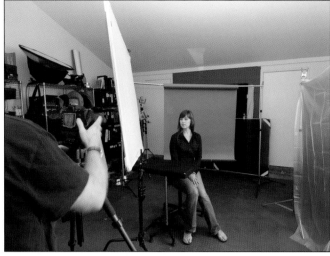

Here's what it looks like from camera position. Notice how the light from the window doesn't fall off from one side of the studio to the other.

The contrast is lowered with the introduction of the fill card, while the light is softened with the introduction of the shower curtain.

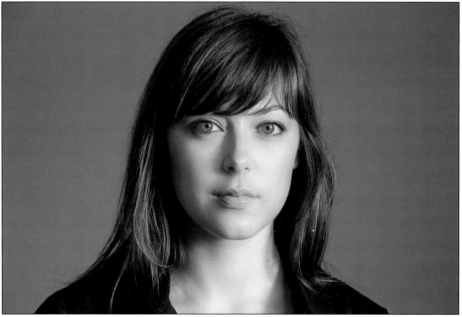

I turned Heidi so that the window would be on one side and shot this image before adding the fill card. It is wonderful to see the range of styles that can be done with just semi-available light.

dio. We put a thick, silver reflector on a Chimera 48x48-inch frame and attached it with a Manfrotto stand clamp to the top of a very rugged light stand. I went in the studio and left Amy outside to adjust the light for maximum effect based on what I saw from the camera position. Getting the most efficient blast of light is really easy, you just have your assistant move the reflector around until you get a huge chunk of light right in your eyes (it's definitely a case of "you'll know it when you see it").

With light streaming through the windows, we set up our $12 (USD) shower curtain to diffuse the illumination just a bit. Then, since we couldn't reposition the sun, we moved Heidi and our background around until we got the desired angle for the main light. Finally, we added a white panel on the opposite side of the subject to provide fill.

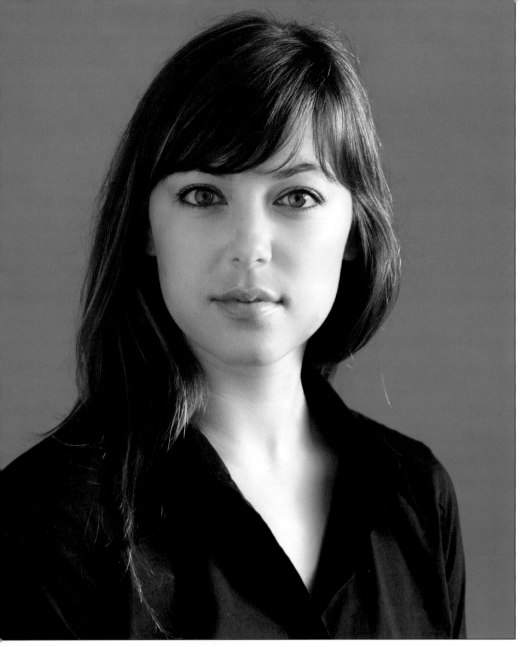

ABOVE—*This is the shot I had in mind when I started. She is angled to the window to give the light a bit of direction.* LEFT—*Here is the overall shot from behind the subject.*

The neat thing about using the sun's light is that the photons have traveled 92 million miles, so the fall-off (see pages 33–36) is almost nonexistent from the edge of the window to the opposite side of the room. We can also run this light for hours with no hit to the electric bill!

My Recommendations (And Predictions)

If you are setting up a studio for the first time and you want to get the maximum bang for your bucks, you'll want to skip the battery and tungsten options and buy an inexpensive set of plug-in-the-wall electronic flash units.

I use the Alien Bees B800 units and have found them to be robust—and a very good value. I have more expensive flashes from Profoto, but I find myself reaching for the Alien Bees nearly every time I go to set up lights. The B800s are rated at 320Ws, which is a meaningless specification. What I really care about is what f-stop I can use when I put a softbox on the light unit and fire it in my small

We can also run this light for hours with no hit to the electric bill!

studio space. On full power, used from about six feet away, I can get f/11 with a nice, low ISO set on the camera. That's all that matters.

I recommend that you buy two 300Ws monolights to start, then add another unit or two when you feel the need. My basic studio kit for portraits is based around two Alien Bees B800 flash units (as of 2008 cost, these are $279 each) and one of the less powerful B400 units. I've used this kit to photograph every kind of portrait shoot from CEOs to crawling babies and it's never let me down. In fact, I first bought these lights (along with their battery pack/inverter [the Vagabond 1.0] for shots that needed big fill but were nowhere near a handy wall plug) for an annual report where I had to crisscross the country shooting for a waste-water treatment mega-company. Basically, I was trying to preserve my Profoto lights and viewed the Alien Bees units as expendables. I packed them in a big Pelican case, but I was certain that 20,000 miles on and off airplanes would mostly destroy them. That was eight years ago! Not only did they survive my travels, they have since been blown over on ten-foot light stands right onto concrete, been dropped, shipped, and dropped again—and I haven't even needed to replace a modeling light. Zero failures!

Whatever brand you choose, there are two important specifications to look at. First, check the recycle time at full power. Anything more than two seconds will eventually frustrate you and make your models impatient. Second, check to see whether or not the units are fan cooled. I only buy units that are fan cooled, because I live in Texas where it's hot and I frequently use lights in enclosed softboxes. The fans keep the lights from overheating and, according to my electrical engineer friends, they make the gear last longer.

You'll also need assorted accessories—and again, Alien Bees is my first choice. Speed rings for attaching softboxes cost me $140 for my Profoto gear. The same type of attachment ring for the Aliens Bees is only $25—and they come free when you buy one of the inexpensive softboxes the company offers! Accessories are covered in more detail in the next section.

I've done my homework, but if you are the kind of person who likes to investigate every available brand, model, and option, you'll need to do your homework online; no single dealer in the United States carries all the different low-budget choices.

In my opinion, it's just a matter of time before the lines are permanently blurred between professional gear and amateur gear. Alien Bees electronic flash units were the first shot across the bow of traditional light manufacturers—and you can be sure that they will return the favor by designing new lights that are smaller, faster to recycle, seamlessly battery operable, and cheaper. At the same time there will always be a market for the professional-grade equipment in studios where cost is no object.

Things You Might as Well Just Buy

We'll cover a lot of stuff that you can either build yourself or repurpose from discount hardware-store products, but there are some things that you are just bet-

Anything more than two seconds will eventually frustrate you and make your models impatient.

ter off buying in their intended form. Unless you are an ace machinist with a lot of time on your hands, these are the accessories you'll need to get started.

Light Stands. Good solid light stands are available in a variety of sizes and weights. Some are made to fold down small and weigh very little. They are no cheaper than a good, solid, mid-range light stand; you are paying for the portability. Since you'll be using them in your studio, though, you really don't need to be concerned about weight. I suggest a set of fairly heavy-duty stands that can be extended up to nine or ten feet. This will come in handy for the times you want to place a hair light up high. Most light stands that come as part of a package are okay if you are just using them with a light-weight monolight and a small umbrella, but you'll want a beefier stand if you decide to use larger softboxes. I use big Manfrotto stands (also branded as Bogen in the U.S.), and I've had them for years. So far, they've been indestructible. I also use smaller stands from Pic—and my favorite tiny stands are the Manfrotto 3373s, which I keep in my location kit because they fold down so small. They're also useful in the studio for holding reflectors, small accessories, and low background lights.

Light stands come in all sizes. You'll probably need a few of each.

Buying stands brand new is one way to get what you need, but keeping an eye on Craig's List and other local online classified ads is much less painful. The photography market is always going through transitions, and you can usually find photographers who are retiring or shutting down their studios and need to get rid of a big accumulation of gear. I've purchased well-used stands for less than $20 each at "photographic" garage sales. If you keep your eyes open, you can too. (You can also improvise with the paint cans and sticks I mentioned on page 58—but don't even think about it if you intend to shoot anywhere other than your studio; I have no idea how you'll pack them for shipping!)

Tripods. Good luck building your own tripod! There are so many inexpensive tripods on the market, there's no way you could build one cheaper yourself even if you wanted to. There are several companies importing Chinese tripods that are very close copies of the more popular brands from Europe—and at half the price or less. If you are using it primarily for studio work, keep in mind that you don't really need your tripod to be super lightweight, so you don't need to look for carbon fiber, titanium, or tripods made from other exotic materials. In fact, a little extra weight on a studio tripod may give it just the mass it needs to be rock solid.

Choose the right tripod for the job. We use the short one when we need to be low and the wooden one when we need something that won't freeze or burn our hands when used outdoors. For everything else we use the Gitzo. It's an old three-series "performance" carbon-fiber model with a cheap Canon ball head on top.

Bogen, Manfrotto, Giotto and others make good, solid tripods that will work well for your studio. Shy away from the skinny, shiny, store brand units. They don't go up high enough or hold your camera steady enough to do the quality of work you probably want to do. I have a carbon-fiber tripod from Gitzo, because I do a lot of location photography, but I also have a much less expensive one from Manfrotto, which is just as sturdy and can be used lower to the ground. I want my all-purpose tripod to go up past my head for group shots, and I also want the legs to be able to extend out at different angles. All the ones I own do that, regardless of price.

The most important thing in selecting a tripod (besides solidity) is how easy it is to attach a camera to the head and how securely the head holds the attached

camera. Bring your camera when you go shopping and try putting it on the tripod head and taking it off, over and over again. The salespeople will think you're crazy, but it's better to find out what you hate about a quick-release system or the way the levers and screws work *before* you've paid for the tripod than when you're out in the middle of nowhere kicking yourself. Everything should clamp down tight with absolutely no wiggle or play. If the tripod you are looking at doesn't meet that criteria, keep looking!

A lot of photographers are very idiosyncratic about their tripods and seem to buy new ones almost as often as they buy camera bags. As a result, tripods are constantly coming on to the used market—so learn where they sell them near you! The good camera store in our town always has five or ten units on consignment. They won't take junk in their used department, so it's a safe bet anything I find there will be of good quality.

Bring your camera when you go shopping and try putting it on the tripod head and taking it off . . .

Your Basic Inventory

So, what would my absolutely fundamental studio equipment inventory consist of? To do basic portraits and small products I would want the following basics:

1. Three light units. These could be battery-powered hot-shoe flashes or budget studio flashes like the Alien Bees or similar units.
2. Three light stands—one for each light. When not holding a light, these can always be pressed into duty to hold a reflector or a light blocker. One of the light stands should be reasonably short so it can be used as a background light stand.
3. Two medium-sized white umbrellas with black backing.
4. Some sort of paper or muslin background and a way to secure it.
5. A decent tripod that goes up high and can be easily rigged to go down low.
6. A bunch of white foamcore panels of various sizes and a few inexpensive "A" clamps to attach them to things.

That's it. If you just want to do good photography in a traditional style, you can stop right there and get to work. Anything else you buy will do things in a *different* way—but not necessarily in a *better* way. More expensive lights might recycle faster . . . but do you really need faster recycling? Not if you're doing portraits or products. More powerful lights might give you smaller apertures, but do you really want the background to be more sharply focused? A thousand-dollar tripod may weigh next to nothing and be solid as a rock—but unless you're hiking in the Andes Mountains instead of moving it across your studio, so what?

Of course, you might need to make other choices if the look or style of the light you're trying to get requires you to use different types of accessories in front of your lights. That could make a real difference—so in the next chapter, we'll investigate the wide, exciting world of light modifiers.

Computing the Cost of Computing

No book on studio photography would be complete without a discussion of the peripheral gear that's required to make digital photography a workable proposition. The biggest expense on any list, after lighting and camera equipment, would have to be the computer equipment necessary to take the raw material of your image files and turn them into the finished products that you are able to license to your clients. This how you can earn money and move the whole enterprise forward.

Computers and Monitors. The prevailing knowledge is that a large, desktop systems with tons of RAM is necessary in order to be successful in the business. I queried local photographers who've been in business for a while and each gave me a variation on this theme: "Okay. The first thing you're going to need is a really fast MacPro (large, traditional, desktop computer) with multi-core processors, tons of D-RAM, and several really fast, 10,000rpm hard drives. Then you'll need two large monitors and a large inkjet printer capable of generating prints that are at least 17x22 inches. Then . . ."

I think these estimates are incredibly misguided and resonate with memories of a time when all but the priciest cutting-edge machines were painfully slow. I learned this in an interesting way. I bought a new MacBook (Apple's consumer laptop, not the "Pro" version) to use on random jobs away from the studio. With Adobe's new Lightroom program, the Intel-chipped laptop (at a little over $1,000) ran circles around my recent-model Apple G5 desktop machine with tons of RAM. The difference was so obvious that I started cheating a bit by hooking up the little laptop to the 23-inch monitor in order to batch process files in about half the time required by my large machine.

The use of the newest multi-core Intel chips has changed the whole paradigm of image processing. Now a $1200 laptop can serve double duty. It can be the perfect location machine for reviewing and storing images in the field and, while hooked up to a calibrated monitor, it can provide nearly the same speed of processing as its brothers in the big silver boxes!

I can't argue that a big machine with more chips and a lots more RAM isn't much faster, but I can say that the speed of even the most modestly set up laptop is a big leap forward from the speeds we used to get using the G4 laptops and the G5 desktops. And let's be honest, most studios that are just starting up aren't processing thousands of files a day. If your business is that robust, you probably already know which computer you prefer and why. For the rest of us, the balance of portability and cost savings is a powerful incentive to wait 20–25 percent longer to finish running a batch of images. The reality is, most of us won't even notice a difference on all but the largest projects. (*Note:* Someone will take me to task for being "Apple-centric," but I mention the Apple machines because I have no personal experience using computer products from any other company. My friends who choose to work on a PC platform assure me that there is very little difference anymore between the two operating systems, and for the most part I agree. I do think, however, that Apple does a great job with software that can

The use of the newest multi-core Intel chips has changed the whole paradigm of image processing.

make my working life much easier—iWeb and Time Machine immediately come to mind. iWeb is the easiest web-development software I have ever used while Time Machine provides continuous, intelligent back-up for my main hard drive, which gives me enormous piece of mind. The message I hope you will take away is not that Apple or Dell make a better computer, but that you don't need to spend a fortune on a "bleeding edge" computer system to handle the day-to-day work of a studio.)

So, what's my budget recommendation for a studio computer on a budget? Get yourself a current MacBook with two gigs of RAM. This is enough power to make great use of Lightroom or Photoshop CS3. Add a nice 23-inch monitor from Apple, HP, or Dell and be sure to use one of the inexpensive hardware calibration devices (often called a "hockey puck"), such as the Pantone Huey or Spyder, to calibrate your monitor for accurate color. Now your computer station is fully equipped—all you need to add is an outboard hard drive to store your files.

So, what's my budget recommendation for a studio computer on a budget?

External Hard Drives. I use FireWire drives because they are fast and reliable. As of June 2008 you can buy an external 500G drive for around $100. I keep a copy of my images on the external hard drive, and I also burn two copies of each file onto DVDs.

Printers. At this point you're done and, if you've shopped intelligently, you'll have spent less than $2000. What's that? I forgot the printer? Hardly. I consider wide-carriage printers to be a money sink. A black hole. A time waster. A misapplication of square footage. They are great for well-heeled amateurs but an unnecessary cost for a studio on a budget. I've owned wide carriage Canons, an Epson 4000 and other Epsons over the years and have found the clogs, the care and feeding, and the difficulty in profiling for so many paper surfaces to be overwhelming. I have small printer that we use to print out bids and invoices (although much of that is being relegated to e-mail), but I've found that the photographic prints I can get from a typical Costco photo lab are far superior to (and much more repeatable than) those my friends and I used to generate on our eclectic collections of inkjet printers.

If I've done my job well, and have used the profiles available for free on Costco's web site, I can get 12x18-inch color prints, printed on real photographic paper, for less than $3 each—about the average cost of the ink I used to use in the process of fine-tuning a test print and then making a final print (if I was lucky and had not angered the "clog gods"). Smaller print sizes are even more economical.

In order to stay profitable and still have free time to spend with my family, I've found it's better to have one job rather than two, so I chose "experienced photographer" and rejected "frustrated lab manager." Some people love to tinker with their prints and constantly test out small adjustments until they feel they've achieved the perfect print. It may be the perfect course for the fine artist, but photographers who are out to make a living with their images just don't have the luxury—or the budgets—to work this way.

4. Zap. Flash. Buzz.

Modifying the Photons You've Got and Making the Light Work for You

You can light stuff by shining your lights directly onto your subjects, you can diffuse the light through translucent or opaque materials, or you can bounce the light off reflective materials in order to modify the apparent size and characteristic of the source before the light hits your subject. Or you can do all three at once.

Anything Goes

You can even modify light using things most people have never thought of using. Many years ago, when I was teaching a studio course on lighting and the view camera, I had a student come in and rip open two large, brown paper bags—grocery bags. She proceeded to make a solid sheet out of the two bags by taping them together with gaffer's tape. Then, she converted the sheet into a large ball. She used the joined brown bags as a diffuser and blasted the light from two flash heads, each set to 2400Ws (a really powerful pop), directly through the bags. The light coming through the other side was gorgeous.

As this example shows, you can use just about anything to modify light that you can think of; it's all trial and error. The following, however, are some of the more common and useful types of tools.

Reflectors

Reflectors can include just about any surface that will bounce light. I've used typing paper, poster board, foamcore boards, plywood painted white, aluminum foil, white umbrellas of many sizes, those round pop-up reflectors you buy at the camera store, white walls, white ceilings, small mirrors, my white button-down shirt, the reflectors they make to put in the windshield of your car in the summer, the palm of my hand, and just about any other flat piece of material that was handy and could be clamped onto a light stand. This is one of the realms of lighting where you can improvise, invent, and save money without having any negative impact on the final image.

How It Works—And Why. So why would you want to use a reflector? The basic idea is that your flash's standard reflector is about seven inches in diameter. You know from reading about the characteristics of light (see chapter 2) that a small light source (relative to the subject) equals a sharper, harder light with more defined shadows. This is what you get when you point that 7-inch reflector directly at your subject. Using reflectors, however, you can increase the effective size of that same light source by bouncing the light onto a much larger surface area,

■ Black Panels

Some of my most-used accessories— and some of the least expensive—are black panels. We generally think of light *producing* fixtures when we think about lighting, but the reality is that sometimes the light we *subtract* is much more critical to the look of an image than the light we add. No matter how nice and soft the light from your favorite light sources may be, it's really the contrast of the dark shadows adjacent to the highlight areas that creates all of the drama. You can buy sheets of foamcore that are white on one side and black on the other. Held in place by a light stand and a clamp, the light-absorbing side of the foamcore is both inexpensive and priceless.

then onto your subject. When you do this, the larger size of the reflector becomes the size of the light source. Nice trick. That means that the quality of light from a dinky, on-camera flash can be as soft and diffuse as the most expensive flash—if both flashes are bounced onto the same size reflector! This is really wonderful.

Practical Example. The cheapest way to begin using reflectors is to use what is at hand. Start by doing a little experiment in your studio. Point a flash or tungsten light directly at the subject and take a photograph. Then, point your flash into a big white wall near your subject and compare the two images. You'll find the difference between the photographs to be dramatic. The image taken with direct light will have bright, specular highlights and hard-edged shadows. The image taken with bounced light off a large, white wall will be much softer. The light will fill in the shadows to a much greater degree and the transition between the highlights and the shadows will be much more gradual and gentle.

The cheapest way to begin using reflectors is to use what is at hand.

Controlling Reflected Light. You need to experiment to find the right size of reflector to use with each type of subject. In shots of small products, I use folded pieces of paper to bounce light where I need it. I use walls of white fabric as reflectors to bounce soft light onto large groups of people. I use small mirrors when I need a highly directional and very controllable "fill spot." Many product shots require small reflectors, which present a good compromise between apparent sharpness and softer edged shadows.

The inverse square law (see page 33) also comes into play when selecting the right size for reflectors. You'll remember that we want to use our lights far enough from a group shot of four or five people so that the light doesn't fall off too quickly as it travels across the group. The inverse square law informs us that moving the light further away from the subject(s) diminishes the falloff from side to side.

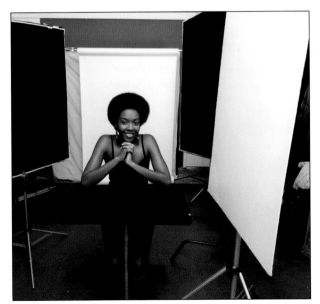

I love foamcore and use it for fill cards all the time. It is light and foldable. I keep a stack of different sizes in the studio.

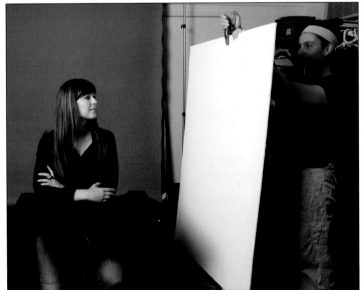

We usually just attach big hunks of foamcore to light stands with big "A" clamps from the hardware store.

ABOVE—*You can make V-flats out of anything. Try getting two large foam-core panels and taping them together along the long axis. When spread at a 45-degree angle, they will stand up by themselves and provide some really nice light. In this setup, I'm just using a couple of Chimera Reflectors.* **LEFT**—*For this image, V-flats were used as a main light over to the left of the camera. The light fixture was a 1000W tungsten.*

However, moving the light farther away from our subjects *also* makes the light harder (see pages 31–32). We can control this characteristic by making the light source larger (by bouncing it off a large reflector, for example). The larger the subject, the larger the light source you'll want to use. Unfortunately, using a large light source at a distance has one disadvantage: it requires either more power from your light source or a higher ISO setting on your camera.

Flat Panels. A simple flat-panel reflector can be a homemade tool—a 4x8-foot piece of foamcore, some shiny home insulating material, or a rectangle of poster board. Shine a light at the reflector board and it bounces off to illuminate your subject. The bigger the panel, and the wider the spread of your light, the softer the resulting character of light you'll get.

If you prefer a store-bought substitute, a number of companies make collapsible, portable flats that are a combination of shock-corded poles and nylon fabric. I own several versions, including the old Lightform Panels that used frames made of plastic tubing, and a newer set of Chimera panels that use thinner aluminum tubing. (Combining three of the Lightform Panels into a triangle makes a good makeshift changing room for models when no other facilities are available on location.) Both versions can be used with a variety of different fabrics for different imaging requirements. The fabrics we use most often in the studio are white, black, and silver. The manufacturers also make various cloths that can be used as diffusers. The two most used are the black and the white. A big white fill is always usable, while the black has become most useful as art director's taste lean more and more to rich, dark shadow areas.

The larger the subject, the larger the light source you'll want to use.

I find panels to be quite useful because they are so easy to fill in shadows with. Place a main light 45 degrees off camera axis in front of your subject, then place a fill card on the opposite side of your subject to fill in shadows and create a more even light. You can fine-tune the effect by moving the panel closer or further away from the subject. This is much easier than adding a second light source and dealing with two sets of shadows and catchlights.

V-Flats. Photographers who work in large, permanent studios sometimes make a versatile type of light modifier by hinging together two 4x8-foot sheets of plywood. They paint the plywood white on one side and black on the other. This gives them a very large, freestanding, V-shaped panel that can be used as a very soft reflector and, when reversed, a large light absorber. The light absorber is perfect for spaces with white walls, because there will be times when you'll want to remove fill light from an image. Big, permanent "flats" like these are inexpensive and will last forever—just repaint when they become scuffed. The only other cost is that of storage.

The same devices can also be made on a smaller scale using foamcore board or any other flat material. A favorite approach to creating a high-key lighting setup for shooting models is to set up a V-flat made of two large foamcore panels, joined by tape, and aim a broad light into the center of the panels. If you back the light up until it is evenly illuminating most of both panels, the light on your subject will be exceptionally soft.

Pop-Up Reflectors. Another family of reflectors is the round, folding type that uses a spring around the perimeter to shape the reflector and hold the fab-

LEFT—*Nothing beats a big 48x48-inch white fill card, no matter who makes it.* RIGHT—*I feel like Alfred Hitchcock for including myself in this book, but there was no one around to hold up my big, translucent pop up reflector. These are great for location work but equally at home in the studio.*

ric rigid. These are lightweight, easy to use, and come in a surprising variety of shapes, sizes, and fabrics. (Several manufacturers even make folding backgrounds that use the same spring technology.) These are available from Lastolite, Photoflex, Westcott, and SP—and probably countless other brands out there that I haven't come across.

There is some variation in pricing, but if you stick with the major brands you'll find them to be of reasonable quality. We have one Photoflex reflector that I have used regularly for over fifteen years with no signs of deterioration! Because they are so light and easy to use, we have examples in almost every size. SP makes a kit called a "Five-in-One," which features one round spring frame, permanently covered with a translucent (shoot-through) fabric and another double-sided, zippered fabric, which allows you to choose silver, black, white, or gold surfaces as needed.

After years of buying and using these springy round reflectors, I find that my two most used variations are the black panels and the diffuser (shoot-through) panels. The one downside of these devices becomes apparent when you want to pack them for airline travel. It's one of those weird compromises—I always want to buy the largest size available, but they only fold down to half their diameter, which means they don't fit in any of my cases. Bummer. That's why I eventually bought the Chimera aluminum tube panels; these pack down into a much more usable set of dimensions.

Diffusion Panels

A long time ago, the movie industry looked at the conventional flat or panel reflector and thought it might be a good idea to make one you could shoot through. Now just about everyone is making a variation of their reflector panels that is designed to be used as a shoot-through or diffusion panel. Most variations are just like their reflecting brethren. Rather than use an opaque cloth, however, they use more translucent cloths that allow light to pass through.

These are available in several strengths. For example, Chimera offers ¼-stop, ½-stop, 1-stop, and 2-stop materials for their system of panels. As implied by the numerical designation, each of the variations transmits more or less light. The thinner the fabric, the "harder" the character of the light. This is a result of more direct, focused light making its way directly through the cloth. We use these diffusers, in addition to our regular light modifiers, to soften and control our main light. For example, I may want to light a portrait subject with a large, diffused umbrella (see pages 73–77) but want the light to be more intense on my subject's face than on their torso. To achieve this, I can block the bottom of the umbrella with a diffuser and selectively soften the light without introducing shadows.

Want to use a screen or mesh to take some light off your main subject without adding any shadows? Try some regular screen material from a hardware store. Sold in rolls big enough to cover a screen door, it can even be folded over for double the light subtraction. Hold it in place with your "A" clamps.

Ultimately, the collapsible panels were engineered with location work in mind. If you are never going on location, why bother with anything more involved than foamcore or plywood panels?

Positioning Reflectors. The universal device for simple, vertical attachment of flat panels to light stands is the venerable "A" clamp (also called welder's clamps and spring clamps). You can buy these at any discount hardware store for a couple of bucks. They come in lots of sizes and are handy for everything. If you need to do precision orientation of your panels, you'll want to buy the right hard-

A mountain of "A" clamps—a must-have for every studio.

A Matthews grip head holds Chimera frames in place and gives you the ability to tilt and shift in several directions.

ware for your system. I use a Matthews grip head (seen in the bottom image to the left) to mount my Chimera panels in my studio.

I find the reflectors to be the most important (and least expensive) accessories I use. If you're just starting out, you might want to invest in a bunch of foam-core and tape and make your own reflectors to start with. Once you learn what styles and what type of light you like, then it makes more sense to branch out into other, more expensive accessories and light modifiers.

Umbrellas

I own umbrellas, which are essentially concave reflectors, in just about every size from around 32 inches up to 80 inches. There are a number of reasons to love umbrellas. First, they are relatively cheap. Second, the light they produce is as soft as that from softboxes of the same size. Third, they are very quick and easy

This photo of Hayes is right in line with my style for certain editorial portrait clients. I use a large softbox or umbrella to the left of the camera, then add a light-subtracting black panel to the right. The background in this photo was lit solely by the edge light from the main light. This was shot with a Leaf AFi7 medium-format digital camera.

to set up and use. Finally, good umbrellas range from around thirty to sixty-five dollars. You can buy umbrellas from the premier manufacturers of European strobes systems, like Broncolor and Profoto. However, that is a lot like buying the floor mats for cars; the ones from the dealers are always four times as much—even though they do exactly the same thing as the department-store ones.

Types of Umbrellas. You can get three basic kinds of umbrellas. First, you can get an umbrella with a white interior and black exterior. Light is directed onto the white surface, which bounces it back onto the subject. The black exterior of the umbrella prevents light from going through the umbrella, meaning you can use them in small, reflective spaces without worrying about light spilling all over the room from the backside of the umbrella and reducing the contrast of a scene by providing unwanted fill light.

Your second option is a plain white umbrella with no backing. On these models, if the white material used to make the umbrella is sheer enough, it can be turned around and used as a "shoot through" umbrella.

For the best of both worlds, you can select an umbrella with a removable black back cover. This allows you to control the spill of light (with the black back in place) or use the umbrella as a diffuser (with the black back removed). Though subtle, the effect of diffused light is a bit different than reflected light and it's great to have both in the same inexpensive package.

A third kind of umbrella features a "silverized" interior surface that offers a much higher efficiency than white-lined umbrellas. As with anything else there are compromises. While the white umbrellas aren't as efficient, their output is much smoother. The silver umbrellas can be very useful, though, as they provide a bit more "snap" (or contrast) for a given size.

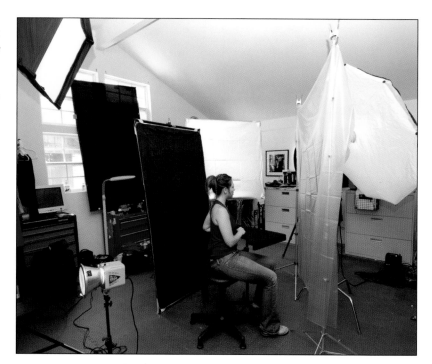

The Photek Softlighter series takes umbrellas one step further by also providing a white diffusion cover for the front of the umbrella, which handily converts the whole thing into a cheap, 60-inch softbox with a very soft quality to the light. Seen to the right of the frame, this Softlighter is my all-purpose lighting tool for people. The quality of light is soft with nice "wrap around," while the cost and portability are unbeatable.

Tuning Your Umbrella. Every photo umbrella has a sweet spot where the umbrella most efficiently makes use of the light from your chosen fixture. It is also the point at which umbrellas are at their softest. Tuning an umbrella works best if you have a really good modeling light in your studio flash head, or if you use tungsten instruments.

Here's what you do. Start by sliding your umbrella shaft all the way in to the light and observing the effect. What you should see is a circle of light centered around the inside of the umbrella. That circle is likely to be pretty far from the umbrella's edges. Then, slide the assembly so that the head is further and further away from the umbrella. At some point, the circle of light will be just about the same size as the diameter of the umbrella. Now your umbrella is "tuned" to your

This shows an example of a well-tuned umbrella.

light source. Moving the head any closer to the umbrella makes the light source smaller, harder, and less efficient. Moving the light instrument further from the head allows light to escape around the edges of the umbrella, which reduces efficiency and spills light around your studio, reducing scene contrast and increasing the potential for lens flare.

If you are using battery-operated flashes and a digital camera, you can move the flash and take a test shot. Continue this process until you can confirm that you've found the "sweet spot." You might want to mark the shaft of your umbrella with a Sharpie so you can quickly tune your light every time you use that particular flash and umbrella combination.

Feathering the Light. When you use an umbrella as your main light in a portrait setup, you can use it pointed directly at your subject or you can use it with a bit more finesse. Every lighting instrument has its own "sweet spot"—an angle to the subject where the light quality is just a bit better. When you set up your portrait lighting using an umbrella, try turning it so that instead of being centered, the light glances by your subject. By doing this, you are using the more gentle penumbra (the edge of the light) rather than the harsher core of the light. Watch the effect on your subject as you slowly rotate the light away from them. There will be a point, just before the light level drops off, where the illumination becomes more interesting. It is a subtle effect, but it's well worth playing with.

My Favorites. My collection of umbrellas includes four-medium sized umbrellas with black backing. These are the perfect tools for lighting white backgrounds in those fashion and product shots where the background must go to white in an even, uniform manner.

My favorite umbrella of all time is Lastolite's 80-inch Umbrella Box. This mammoth umbrella does everything the 60-inch Photek Softlighter does—and it's even softer. So why in the world would you want (or even need) an 80-inch

A large white sweep background requires four lights to guarantee even light coverage. Umbrellas with black backing work best since they don't spill light forward onto our subjects. This shoot will be covered in greater detail on pages 113–15.

umbrella/softbox? I didn't really have the answer to that when I bought it, but I used it on a shoot in a most novel way and now I'm addicted to the "hard/soft" effect. Let me explain. Used close up, most umbrellas give a nice soft, wrap-around light that's very flattering to a subject's skin. As you move the umbrella further and further from the subject, the light gets harder and harder. With an 80 incher, you can move the umbrella back twenty or thirty feet and still have soft light with minimal fall off from one side of your subject to other. It's an interesting effect and probably easier to show than to explain. In order to use this particular technique, you'll need some lights with some "oomph" to make up for the light lost over the distance.

My Recommendations. What do I recommend? Everyone should have one medium sized umbrella like the 46-inch Softlighter (with supplied diffusion front piece) and at least on 60-inch umbrella. I consider the 80-inch umbrella critical only if you are seriously obsessed with both giant umbrellas and ridiculously soft light.

Be aware that, even though I've tried to wedge all umbrellas into three distinct groups, the powers of product differentiation and niche marketing march on. Many mutant variations of the basic umbrellas exist. For example, several Euro-

As you move the umbrella further and further from the subject, the light gets harder and harder.

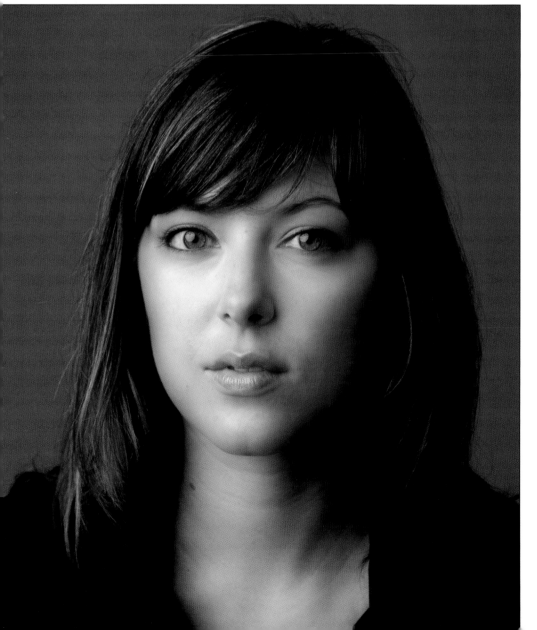

You'll love the skin tones you can get using an 80-inch umbrella in close to your subject. No fill card required.

pean companies market Zebra umbrellas. These have alternating patterns of white and silver for photographers who just can't decide. I recommend that you stay with the simple solutions. They are time- and photographer-proven and most cost effective. If you can't find a good 60-inch umbrella for less than $80 and a good selection of 40- to 48-inch umbrellas for under $50, you are definitely shopping at the wrong store or web site!

This is my budget answer to the famous Octabank made by Elinchrome. This Lastolite 80-inch softbox comes with its own front diffusion already in place.

Softboxes: Origami Meets the Umbrella

Softboxes are based on a great idea: create a lighting accessory that yields uniform soft lighting without spilling light anywhere you don't want it to be.

The Birth of Softboxes. Softboxes were created by studio photographers who were out for total control. These photographers loved the way flat-panel diffusers created a soft light with no weird reflections showing in the subject highlights. (When umbrellas are used, you can often see the ribs of the umbrellas in the reflections of people's eyes and in any large highlight areas.) The problem with flat diffusers in the studio, however, is that a tremendous amount of light reflects off the back surface of the diffuser and spreads all over the room. In a white studio space, this "spill" bounces around, creating its own fill light and reducing the contrast of a carefully constructed lighting design. The light wrapping around the edges of a flat panel can also cause lens flare when the camera position is adjacent to the edge of a big reflector.

At first, photographers used black panels to try to "flag" (block) the spilling light. This was a decent solution . . . as long as panels stayed on the floor. Eventually, however, the photographers wanted to move their whole lighting apparatus around—maybe suspend it over a set or place it at a high angle to a model. This made the whole process of trying to flag off the light very cumbersome and called for lots of additional light stands, black panels, and clamps. The complexity made the lighting setup very impractical, limiting a photographer's freedom to tweak the light and move things around.

The solution was to create an enclosed light panel. The first variants were homemade, but soon light manufacturers created large, heavy, metal softboxes that required their own (extremely stout) dedicated light-stand systems.

Finally, several American companies took a look at mountain tent technology, using flexible fiberglass poles, and created the cloth and fiberglass softboxes that we recognize today. The biggest benefit, in addition to ease of use in the studio, is the sheer portability of current softboxes. Now it is easy to pack a 5x6-foot

My photograph of Anne Butler is the ultimate distillation of the style I like in portraiture. The pose and expression are quiet and thoughtful. I used a very large softbox (50x70 inches) with two layers of white diffusion fabric pinned to the front panel. The softbox is touching the side of camera just to the left, and a black cloth was used to absorb the light that would normally be reflected off the wall to the right of the camera position. This increased the intensity of the shadow on Anne's face. Several gridded flash heads were used (along with a small softbox) to light the draped cloth in the background. While I used a commercially made softbox, it is a style that can be improvised with hot lights and bed sheets, if necessary.

softbox for use on location. Even a monster softbox can be set up and ready to go in ten minutes (with a little practice). These devices attach to lighting units with speedrings (which are an integral part of the softbox structure) and one unit, with appropriate speedrings, can be used with most of the major brands of electronic flash lighting on the market today.

What to Purchase. I think that softboxes can solve a lot of small-studio problems by eliminating lighting backsplash, but it's pretty easy to go overboard and use them all the time. Many photographers buy one softbox, generally a medium-sized one (such as a 24x46-inch or 36x48-inch model) and then use it for everything. A softbox that's too small doesn't cover large scenes or groups of people very well, because the light source is too small in relation to the subject. This adds lighting contrast and creates more defined shadows than you might want. A softbox that's too large, on the other hand, tends to flatten out the contrast and minimize the directionality of your light, so it's not always a great choice for smaller objects or single people. Therefore, if you decide to use softboxes and you shoot lots of different types of images, you'll probably want to buy three different sizes: a small one for small objects (also very usable to light backgrounds); a medium one for single portraits and tight table-top still lifes; and a large one for groups of people, large still lifes, and really soft light at a distance.

I think that softboxes can solve a lot of small-studio problems by eliminating lighting backsplash . . .

If you are a portrait shooter, start with the largest box you can comfortably afford and wedge into your studio space. Even though conventional theory says a 6-foot softbox is too big for a single portrait, I use one to do single portraits all the time. I like the really soft character it gives the light and, if I think it's too big, I can mask the sides or the top and bottom to custom create a specific size. If you are a still life shooter, get the biggest size that you can use on your boom in your studio over your shooting table.

Once you master the largest unit, you can always work backward through the smaller sizes. Keep in mind that, for 90 percent of applications, a Photek Softlighter (see page 74) with a front diffuser panel will provide just as nice and soft a light as a 6x5-foot Chimera softbox at about a quarter of the purchase price.

The Pros and Cons. Here's one reason to hate softboxes: To assemble large softboxes, you need to get the bent poles into a highly flexed position in order to get them into the holes on their speedrings. Unless you have very strong hands you will have a lot of difficulty doing this—and taking it apart is even worse. If it is possible, go to the store where you intend to buy your softbox from and ask a salesperson to demonstrate how to assemble and disassemble the unit you are planning to buy. If the process is still a mystery to you, reconsider those beautiful, big umbrellas.

In fairness, though, there are a number of reasons to love softboxes, too. Since there is no protruding center rod (as there is with umbrellas), softboxes can be used much closer to your subject. This will increase the apparent size of the light source in relation to the subject, rendering a softer lighting pattern with a strong sense of directionality. Softboxes also tend to have a more limited spread than umbrellas, which gives you more control over spill. When you are trying to keep a background dark, it's easier to use softboxes. Some manufacturers even make grid attachments for their softboxes. These allow you to concentrate all of that soft light into a much more collimated light beam with less chance of reflections—and their attendant lowering of contrast.

The basic selection of parabolic reflectors for a Profoto monolight. The large one throws a fairly moderate beam of soft-edged light. The small one is designed to be used with umbrellas, and the medium one is just right for everything else.

The Overlooked Lighting Modifiers

Parabolic Reflectors. Photographers love accessories they can put over their lighting instruments. In many cases, the soft light these create is easier to work with and less technically threatening. But you don't want to overlook a much smaller beam modifier: the good old parabolic flash reflector. Most electronic flash heads or monolights come with these metal reflectors that clamp or bayonet to the flash head and direct the light in a mostly frontal direction. A huge range of these parabolic reflectors are available for

most models of flash head. Most are made of lightweight metal that is either polished (for high efficiency) or textured (to make the light a bit softer). The stock parabolic reflectors are fairly small in diameter, usually six to eight inches. This makes their basic light quality very contrasty and harsh. Most also spread the beam of light anywhere from 70 to 90 degrees.

Beauty Dishes. At the other end of the scale are what have become known as "beauty dishes." Like parabolic reflectors, beauty dishes (which are are available from most lighting manufacturers) feature a shallow metal bowl. However, beauty dishes are much larger, from 22 to 28 inches in diameter. They also have either a dull silver or matte white interior and a small metal plate that sticks out in front of the flash tube, directing all of the frontal light back into the reflective bowl. If you want to soften the light a bit more, you can attach a "sock"—a white, nylon diffusion panel placed on the front of the light to make it more like a small, round softbox than a hard reflector.

The beauty dish features a lighting flavor that is very popular at the moment, particularly with portrait and fashion photographers, because it offers a good blend of hard, direct light with a fairly soft edge. Used on axis, the light is flattering but flat. This is perfect for subjects with less-than-perfect skin tone. Used to one side, it gives a very nice modeling of a subject's face, but it will accentuate defects in skin tone. If you like the look of your light off to the side (And who wouldn't? It adds such nice drama to a portrait.), you quickly learn how to soften detail in Photoshop without losing detail in lips, eyes, nostrils, eyebrows and hair.

Spill-Kills. One of the benefits of buying into the more expensive brands of lights is generally their deep selection of very specific and beautifully designed flash-head accessories. Each one designed to solve specific lighting problems effectively. The spill-kill, for example, is a smaller, flatter reflector that is designed to be used with any umbrella. Basically, it provided a "backstop" to prevent direct light from spilling back into the subject. These are small, light, and recommended for anyone using umbrellas.

Magnums. The magnum is a big, deep reflector that narrows and intensifies the light beam from the flash head. These are very useful for placing a large dollop of light onto a large flat diffuser without a lot of spill around the sides.

Grids. The most useful attachment for a standard metal reflector is, without a doubt, a grid. This device concentrates the light rays into a collimated pattern, giving you a much smaller spot of light than you'd have without it. Grids come in a range of strengths and are usually referred to by the angle of spread they produce. So you might have 10-degree, 20-degree, and 30-degree grids to choose from for your flash head/reflector combination. (You could also concentrate the light from your system with a snoot, but the advantage of grids is the softly feathered edges they produce.)

The tight spot produced by the right grid is absolutely great when you need a touch of light in a very small part of a shot. Grids also work well when used on background lights. When used on accent or hair lights, their tightly focused light

The most useful attachment for a standard metal reflector is, without a doubt, a grid.

Straws: Not Just for Frozen Margaritas Anymore

Want to use grids but don't want to spend the money for them? Try black cocktail straws instead. These straws are the ones with a diameter of about an eighth of an inch and they are shorter than drinking straws made for sipping on sodas and milk shakes. You'll need a bunch, so you might want to source these from someplace like Costco. Because of size considerations, this works best with small, battery-operated flashes, but it can be adapted to larger flashes.

Here's the drill. Bundle together enough straws so that they cover the diameter of the front of your flash's standard reflector. Then, wrap black tape around the circumference of the assembled straws in three places. You don't need the straws to be very long to give you the effect you want, so use a very sharp, finely serrated knife to carefully cut the tube so that you have about an inch of straw parts that are uniform. The tape should hold them in a bundle. Use additional tape to apply it to your light.

A word of caution: if you are using a studio strobe, don't use the modeling light with this device in place. The heat from a 100W bulb will eventually melt through the straws and cause smoke and a mess.

beam helps to reduce light spread that can cause flare if it strikes the front element of your lens.

The only real problem with grids is the cost. Profoto sells a grid holder for $175 and a set of three grids will cost you at least an additional $300. That's big money. But if you need a grid for your handheld flash or your studio flash head, all is not lost. The secret is black drinking straws—seriously. This is covered in the sidebar to the left.

Hair Trigger: Getting All Your Lights to Fire on Time

Just like getting all your friends to show up at the same restaurant on time, getting all of your flashes to fire at the same time can be frustrating. This is one problem you can totally avoid by using tungsten and fluorescent lights; because they are continuous, they are always synched. Flashes, on the other hand, tend to be problematic.

Sync Cables. If I'm using one monolight or a pack-and-head system, I tend to go with the old-school method and just grab a sync cable and go. They work until they die and the whole thing is very binary.

The fun begins when you add two or three separate light sources and you need them all to flash at once. It's not practical to wire them all together with sync cords (although that is exactly what photographers did back in the days before sync slaves and radio triggers were invented). Therefore, I tend to go in steps from the easiest and cheapest solution to the most expensive. I only escalate when my preferred (i.e., cheaper) option isn't working.

Optical Slaves. Most "plug in the wall" flash systems made in the last five years feature built-in optical slaves that can see a flash from another source and flash in tandem. The good ones are very reliable indoors, but they generally can't "see" around corners and have a limited distance range. Still, used as intended they do a great job.

When I will be depending on the built-in optical slaves, I generally grab a portable shoe-mount flash, dial the power in the manual setting down to the $\frac{1}{16}$ setting, and put it into the hot shoe of the camera I will be shooting with. The flash on the camera is generally aimed toward the ceiling to keep it from adding light to the scene. In my small studio space, I am able to trigger the rest of my strobes nearly 100 percent of the time with this method.

Radio Triggers. When the built-in optical triggers and the on-camera flash fail me, I move on to step two: radio triggers! A couple of years ago, I bought a cheap set of radio flash triggers that were being marketed by RPS corporation for around $100. That bought me a transmitter that sits in the camera's hot shoe as well as a receiver with a standard sync socket and a separate sync cord with a $\frac{1}{4}$-inch plug on it. If you keep up with the batteries, these guys can be very reliable. They pretty much work all the time at distances up to forty feet. I rely on them to shoot in bright daylight.

If budget is no issue and you do the kind of photography that requires greater range and 100 percent reliability, then you are probably in the market for a brand

This is an inexpensive radio transmitter used instead of a PC cable to trigger flash units.

of radio triggers called Pocket Wizards. At roughly four times the price of the RPS units, you get a greater range with more certain firing. In most studio situations, however, there won't be a demonstrable difference between the two sets.

Infrared Triggers. If you use the latest battery-operated, hot-shoe flashes from one of the big Japanese camera manufacturers, you might want to consider the infrared controllers they make. It's a nice way to control the power output of multiple flashes, and the controllers can allow you to use automatic settings with your flashes. I like the infrared controllers, but I'm not very interested in automatic flash settings. As you'll see in the following section, I like to set the power levels on all of my flashes manually. Why? So they all do the same thing every time the shutter goes off. No variation equals a happy photographer!

Other Options. In the next few years, I'm sure you'll see most lighting manufacturers offer units with built in WiFi or Bluetooth connections that will allow photographers to wirelessly make all sorts of adjustments to their lights in the typical studio. The new light controllers will be programs on our laptops— and eventually even programs on our cell phones.

I like the infrared controllers, but I'm not very interested in automatic flash settings.

The Manual Mode

Many photographers have asked me what modes or setting I use on my cameras and my flashes for my photographs. In all but the most chaotic situations, I'm pretty happy using everything with manual settings. If I'm shooting my kid's swim meets, for example, I find that the light really doesn't change much, but the different reflective surfaces and colors do throw off the built-in meter. If I use the manual controls in those situations, I spend less time in postproduction fixing little ups and downs of exposure.

When using the flash on my camera to shoot a group of people at an awards ceremony or other formal event, I find that the men's dark suits tend to fool the TTL flash and cause the flash to overlight the images. In those situations, I pre-set the flash based on the distance. In the old days we referred to that as "guide number settings."

In the studio, there is always going to be a fixed amount of light striking a subject at a fixed distance. As soon as we figure out what the correct exposure is, we tend to lock it there and not change anything unless we change a light in a scene. This way, I can be sure that if I move the camera a bit to the left or right the exposure won't change. If I were using an automatic setting, a move several feet to the left or the right might cause the in-camera meter to see a new spot of black or white and change the exposure.

I also find that automatic exposures in these settings tend to be constantly changing, so that instead of being able to batch process images at the end of the day, we spend a lot more time fine-tuning the exposure of each frame. Not a good use of time!

Incident Metering

When I design the lighting for a shot, whether on location or in a studio space, I usually have an incident-light meter around my neck and I use it extensively. It's a shot saver and a time saver. You might find it counterintuitive to buy a hand-held light meter when every new digital camera comes equipped with its own re-flected-light meter and histogram readouts—but, trust me, you need an incident-light meter.

Every light meter is designed and calibrated to do the same thing: read the illumination in a scene and give a reading that will render that scene as an 18-percent gray average mix. For example, if you use a spot meter, a type of narrow-reading reflected-light meter, it assumes that whatever you point it at either *is* or *should be* 18-percent gray. That's the target on which the exposure readout is predicated.

As a result, if you point any reflected-light meter at a scene that is predominantly dark, say a woman in a long black dress against a dark background, the meter will try to make the scene lighter. Conversely, if you are photographing a woman wearing a white dress on the beach the camera's internal (reflected-light) meter will try to darken the overwhelming brightness of the scene, causing serious underexposure. (*Note:* Even with the multi-point and 3D meters in the most advanced cameras, the little computers in the cameras are trying to make sure that no highlights burn out and that the average of the metered points conforms to a given value as represented in a memory bank of scene algorithms.)

Another problem professional photographers have with built-in meters, no matter how good their readouts, is that when lighting a white background it's almost impossible to know whether you have enough light on the background or too much. The lines on the histogram just bunch up on the right side! Too much light on the background causes light to bounce back to the subject. This creates

This way, I can be sure that if I move the camera a bit to the left or right the exposure won't change.

■ *In a Perfect World*

In my dream studio, I would have about a hundred feet of depth to work with when shooting portraits. I would place a background against the back wall and put my portrait subject about sixty feet in front of the background. My camera would be twenty feet in front of my subject, allowing me to use a nice long lens for the portrait. The result would be a creamy, soft, perfectly lit background and a subject rendered with perfect perspective. In a smaller studio, though, we learn how to make do with what we've got.

unwanted rim lighting and can cause lens flare that seriously degrades the contrast and detail of the photograph.

Unlike a reflected-light meter, which reads the light *bouncing off* the subject, an incident-light meter reads the that's *falling on* the integrating dome on the meter. If you use the meter correctly, placing it very near the object you'd like to measure and pointing it back toward the camera position, you'll measure the exact amount of light falling upon your subject—regardless of how light or dark the subject is. Since the light measurement is unaffected by subject color, tone, or reflectivity you will always have a more accurate starting point. In fact, this is why cinematic directors of photography (the people in charge of lighting movie sets and locations) always use incident-light meters before running thousands and thousands of dollars worth of film through their cameras!

This is the proper method of incident-light metering. The dome of the meter points back to the camera position. This is much more useful in the studio than a reflected-light meter.

I should note, however, that whether you use your in-camera light meter or a dedicated incident-light meter, the readings are just a starting point for interpretation. Exposure must ultimately be judged by looking at your images. If this is difficult to evaluate on your camera's LCD, take the time (whenever possible) to double check your results on a computer monitor.

5. Putting It All Into Play: Portraits

Now that you've decided on your lights, let's start playing with them and understand the way they work and what the effect is. We'll start with umbrellas and work our way through our favorite portrait lighting setups. In the next chapter, we'll do the same thing with still-life images.

The One-Light Portrait

Let's start with a scenario that we'll all face: the one-light portrait. Here, we build it one step at a time. Let's start by looking at our model in front of a gray background using just the available light that's coming through the windows. The light is soft and directionless and gives no modeling to our subject's face. As the light bounces throughout the room, and the light bouncing from the white walls and the ceiling lower the contrast of the scene.

Heidi was photographed with just the light coming in through the windows.

With no lights, here is the wide view.

Now, let's add a single light. In this example, I've set up an Alien Bees strobe with a standard reflector. I placed the light directly in front of my model, then moved it in an arc until it was about 45 degrees to camera left. As I did this, I looked for a little triangle of light surrounded by shadow to appear under the eye on the opposite side of her face from my light. This is my standard method

for positioning my main light for most portraiture. With the light set at the right position (see images below), we can see that the light is hard and specular. It brings out a lot of surface texture, which is rarely welcome in a portrait, and creates a harsh transition from highlight to shadow.

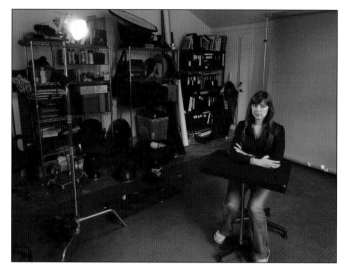 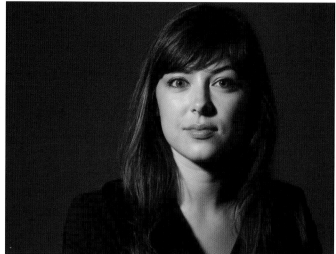

Here's a basic setup with the main light 45 degrees to camera left. *And here's the result: deep shadows and sharp lines.*

Next, let's switch to umbrellas. We'll start with a small (32-inch) umbrella with black backing for the main light (see image below, left). The resulting light is softened and the transition from light to dark is more pleasing. I think the 32-inch umbrella is too small for a flattering portrait, so let's exchange it for a 45-inch Photek umbrella. The lighting is softer but not dramatically so (see image below, center). Finally, let's exchange the 45-inch unit for a 60-inch umbrella. Now the transitions from highlight to shadow are very graceful. The wrap-around quality of the larger modifier helps to smooth the skin texture and it does a better job spreading to the background (see image below, right).

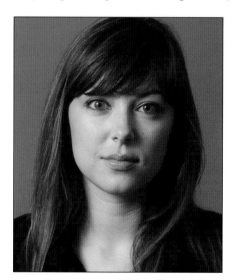 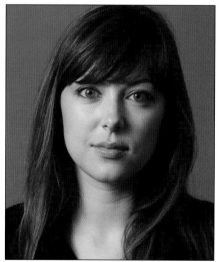 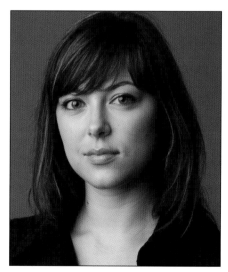

LEFT—*We used a small 32-inch umbrella as our main light. Notice how the light spill illuminates the background.* **CENTER**—*A 45-inch umbrella offers little discernable effect (versus the 32-inch umbrella).* **RIGHT**—*Large umbrellas with very little fill are my favorite tools for lighting faces. Here, I've switched to a different brand of 60-inch umbrella than was seen in the previous shot and used it with no fill.*

Let's further modify the image by adding some fill reflection to the other side of the subject. We'll just use a chunk of white foamcore. The result is a reduction in total image contrast, a filling-in of skin texture, and an even softer transition from highlight to shadow. Additionally, the shadow areas show more detail.

The only real issue with this one-light image is a background that may be on the dark side. We can cure this by letting more light strike the background and

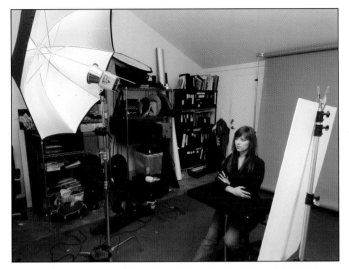

Here's the overview of our 60-inch umbrella shot with the foam-core reflector just to the right of the camera.

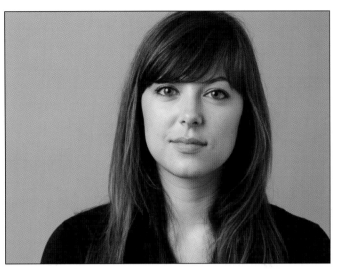

Adding a fill card to the shot opens up the shadows and bounces more light around the room and onto the background.

reducing the amount of light that is striking our model. For our final example, I placed a translucent diffuser in front of part of the light from the umbrella, then turned the umbrella so that more light spilled on to the background (see image below). This technique works well with all one-light setups, whether you use plain reflectors, umbrellas, or softboxes.

I love using light blockers and diffusers to change the distribution of light instead of having to use more lighting instruments. Here, a diffuser blocks some of the light on Heidi while unobstructed light hits the background.

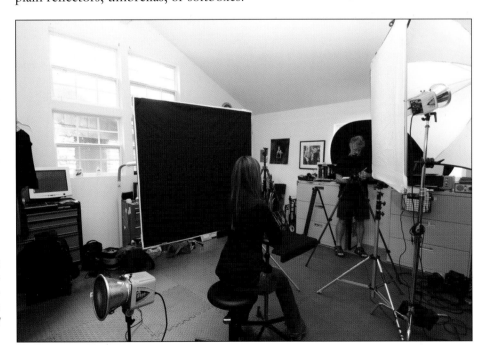

Adding a Second Light

Given a second light source, many beginners press it into service by adding it as a fill light. Indeed, photographers used to depend on a second light for fill, but large flat panels or big pop-up reflectors create a more natural look and require less equipment, fewer power cords, and less setup.

With this in mind, the most important use of a second light is to illuminate the background and help separate the subject from it. In this example, we use our second light (with its supplied metal reflector) as a background light. In comparing our image with and without a real background light, you will instantly see that the second light source, used in this way, adds a sense of depth to the image.

Using a second light for the background will also allow you to position your main light without having to rely on its spill or power to help illuminate the background. This means that you are free to move your subject as far forward from the background as you would like. The benefit? The further you move the subject and your camera from the background, the more out-of-focus the background becomes. Diminished focus on the background eliminates random details that attract the viewer's eye and take away attention from your main subject. When using a second light to light the background you can also control the size and shape of the light on the background and how quickly it falls off from its center.

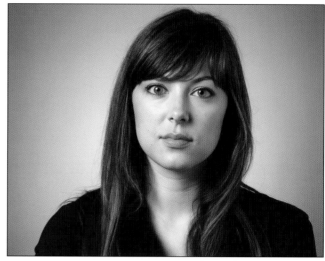

Our final permutation of the shot we started building on page 85 includes both a fill reflector to camera right and a gridded background light.

Adding a little bit of glancing backlight from the rear of the set gives additional depth cues.

Adding a Third Light

Adding a third light is always interesting. The role of the third light should be that of an accent light.

Rim Light. This can be positioned directly behind the model and pointed back toward camera position. The model will block the direct light and be subtly rimmed by highlight.

Hair Light. Alternately, the third light can be used as a hair light. In this application, the light must be carefully positioned so that it lights only the subject's hair. It should not be so far forward that it casts light on the subject's forehead. If I use a hair light, I adjust it to a very low power setting; it is just there to offer a bit more separation from a dark background.

Glancing Backlight. The third use of a third light is as a glancing backlight. This is placed behind the subject on the side opposite the main light. Rather than allowing the subject to block the light, however, it directly strikes the subject's cheek on the shadow side of the frame, adding a bit of fill and a specular highlight. This look is currently cropping up more and more in fashion photos. It's also used to provide a bit more separation when using a dark background.

My Favorite Way to Shoot a Portrait

I love the look of a very soft but very directional main light that sweeps across a subject's face to add dimension and depth. The light must be soft enough to keep from accentuating pores and flaws but directional enough to yield a deep, rich

LEFT—In this angle you see: (A) the Photek 60-inch Softlighter umbrella with diffusion cover; (B) My Target shower curtain for an additional interesting diffusion effect; (C) a black, light-absorbing panel to preserve a rich shadow; and (D) a reflector that is partially blocked by the black panel. RIGHT—This angle shows the backlight that will separate her hair and shoulders from the background, as well as the background light with a grid on it.

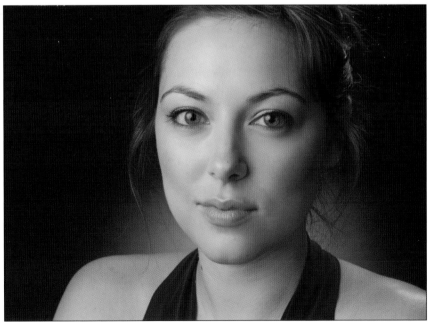

LEFT—This is the finished shot with all the elements in place. It was shot on a Leaf Systems AFi7 medium-format digital camera with a 180mm f/2.8 Schneider lens. RIGHT—This version was shot on a Nikon D300 using the 60mm macro AFS lens and shows a totally different feel and perspective.

Be prepared technically so you can build a rapport with your sitter.

shadow on the opposite side. The following images are different views of my favorite lighting setup with information about the lighting details in the captions.

Some Additional Tips for Portraiture

Before we move on from portraits I have a few hints to pass on that should make your sessions a little less frantic.

Set Up and Test in Advance. If at all possible, set up and test your lighting well before your subject arrives. Even for the most rudimentary of headshots, I try to be set up, metered, and ready at least an hour before my subject is sched-

uled to arrive. Endlessly fussing with the lights while they are sitting and waiting for you sends several messages. First, it says that you are not confident working with your tools. Second, subjects may take your constant resetting of lights personally—perhaps thinking that their face is so ugly or misshapen that you are struggling to deal with the aesthetic ramifications.

Every modern digital camera comes with an electronic self-timer. When I'm in a dinky conference room, or setting up in my studio and working without an assistant, I try to get the lighting where I think it needs to be, then I sit in the subject position and use the self timer to take an photo. The composition is usually not optimal and sometimes the focus is a bit off but it's easy to tell if the lighting ratio is off or if there is an unwanted shadow in the scene. It's all part of "fumble control."

Show them, by example, exactly what you'd like them to do.

It is easier to overlook a wrinkle in a shirt or a stray hair than it is to overlook the "deer in the headlights" look that comes across a subject's face when you spend too long fumbling around with your gear. Achieving good expressions means developing a fluid and efficient working style.

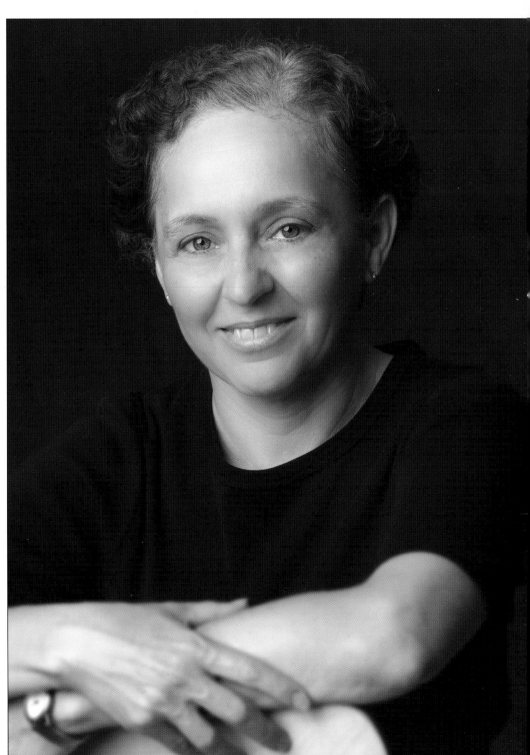

Have a Plan. Have a plan before you start shooting. You can always change your plan once you start, but you should know what you want to come away with before you get down to business. I aim for a good general use headshot, a smiling shot, a serious shot, and usually a standing portrait. If I find a really great angle or expression, I'll adapt and try to elaborate on that. Remember that you'll have to edit whatever you shoot, so don't lean on the shutter button too much.

Fix It Immediately. If you see something that's not right with the subject's clothes, hair, makeup, etc., try to fix it right then and there. It's easy to say that you'll fix it in post-production, but why create hours of extra work for yourself? A few extra minutes and a bit more attention during the shoot will save you the agony of trying to fix a poorly positioned tie or a necklace with a mind of its own.

Give Direction. People want to be directed—really *directed*. If you are used to just sitting someone down, telling them to "smile," and hoping that they will naturally fall into a perfect pose, you really need to start taking charge. Show them, by example, exactly what you'd like them to do. Once you have them posed the way you want, start working on small refinements. This might mean turning their head just a few degrees or having them lift their chin slightly. If your verbal directions don't seem to be getting through, the best method I've found is to have them come over to the camera position and watch me. I then take their place on the posing stool or on the background and show them exactly the expression and the "body language" I have in mind. This level of direction gives them confidence in your ability, breaks the ice, and may be the difference between a good image and a great portrait.

Take Your Time. Finally, don't hurry. Your sitter or model is just as invested in a good outcome as you are, so take your time and think things through. Take a break and get to know the subject better. Talk to them about their kids or their hobbies. If the light isn't working, take the time to change it. In short, you need to "own" every aspect of the session to ensure that it is successful.

Be Prepared with First-Aid Makeup. When taking portraits, don't underestimate the advantages of learning how to apply makeup—or, better yet, hiring a makeup artist. All the cool lighting instruments in the world won't amount to much if your portrait subject has a big, bright, specular highlight glittering across their forehead. While a large, soft light will make the highlight-to-midtone transitions more graceful, the fact remains that blown-out highlights are one factor that screams out "beginner!" And I don't care how good you are at Photoshop, retouching burned-out highlights is just about as much fun as cleaning your bathroom.

Even if you work with a great makeup person, there will be times when one of your personal projects won't have the budget to include their services. Other times, you might not be able to schedule a talented makeup person on short notice. For these mini-emergencies, it behooves you to put together a small makeup kit. The bare-bones kit would include: basic facial powder in three shades; plain lip gloss; big, fluffy powder brushes; some foam wedges to blend the powder with; and a little spray bottle filled with alcohol. A valuable extra would be a

Once you have them posed the way you want, start working on small refinements.

We needed a kit to stash our makeup in for just one job. It only had to last one week, but it's currently celebrating its sixteenth birthday.

packet of oil-absorbent wipes. These are little sheets that resemble tracing paper and soak up facial oil when rubbed across your subject's face.

Here's how I approach emergency makeup when there's no one around I can coerce into acting as a designated makeup person. Once I've determined my subject needs a little help to tone down the shine on their face (or bald head), I put a cloth or makeup apron over their clothes. This keeps light-colored face powder off their dark suits and black turtleneck sweaters. Then, I hand the subject several of the absorbent sheets and ask them to wipe off the shiny parts of their face— usually their foreheads, noses, and chins. The second step is a gentle application of powder using one of the big (one- to two-inch wide) makeup brushes. Finally, I do a quick overall blend of the powder with a little foam wedge just to make sure there are no visible powder grains. That's all I do.

A gifted makeup person is a great part of a photographer's team and can make a world of difference in the look of your subject. I view my intervention as more of a quick fix for optimal lighting than a cosmetic change. The better the application of the makeup, the smaller and more intense the lighting instruments you can use without having to worry about the dreaded "blinking highlight" indicator on the back of your camera. In fact, if you are doing dramatic lighting from severe angles, it verges on cruel to proceed without the kind protection of a few cents worth of makeup offers.

The key to "first aid" makeup is to make it invisible but useful. For most subjects, your real priority is to get rid of the shine. (A quick note: The spray bottle of alcohol is included in the kit so that you can quickly sterilize your brushes and make them ready for the next makeup adventure.)

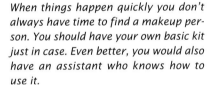

When things happen quickly you don't always have time to find a makeup person. You should have your own basic kit just in case. Even better, you would also have an assistant who knows how to use it.

6. Putting It All Into Play: Still Lifes

Your Objectives

Before we get into the nitty-gritty, the following are some tips for surviving and thriving with still-life photography.

Decide on a Camera Angle. Establish your camera angle and elevation first. Moving your camera after you've lit a scene may cause reflections and shadows you'll have to spend time fixing.

Create a Look and Feel with Lighting. Your lighting should be designed to accomplish a visual objective. This means that you should have an idea in mind for the look of the scene before you even start lighting. Establish a dominant light that provides the desired overall character for your scene, choosing side lighting if it's important to show texture and volume. Then, begin to add fill reflectors, mirrors, or additional lights that support the logic of the primary light—but don't undermine your side light by using too aggressive a fill light.

Play with the quality of the light. Think about whether you want soft, smooth transitions (bigger light source) or whether the texture of the object you are photographing is more important (softer light used a greater angle from the camera axis). You can modify light by shining a focused source, such as a spotlight or gridded reflector, through bubbly glass bricks, sheets of diffusion materials with randomly cut holes or shapes, or by bouncing it off rippled reflector sheets. It's all about experimentation.

Evaluate from the Camera Position. Always judge the results of any lighting change in the scene from the camera position. Over the course of an assignment, an assistant, art director, or client will often make a comment about an scene we've lit and not understand that the image looks totally different from the camera position. When we show them a Polaroid (old school) or the image on a laptop they instantly get it. So, anytime you are judging the direction of shadows, reflections, or quality of the light on the scene be sure you are looking through the viewfinder of the camera!

Consider Continuous Sources. If your subject doesn't move and won't melt, you can use any kind of light to realize the final image. I like using tungsten fixtures in these conditions, because it is so easy to see exactly what you are getting while you are setting up the lights. Since you are in control of the color temperature and time, even the cheapest and least powerful lighting instruments can give you perfect results in still-life photography.

Adjust the Color Balance. Think about changing the overall color balance to make an emotional statement with the image. Warming up the overall color can

The best piece of advice I ever got about inanimate object photography was to remember that the angle of incidence is equal to the angle of reflectance (or, if you prefer the hoary cliché, "It's just like playing pool with light!") Basically, it's all about sixth-grade geometry. If you shine a light from close to camera position directly onto an object, that light will reflect directly back toward the camera. At best, with a matte object, the light will be boring and do nothing to add to the feeling of depth, define texture, or reveal much about the character of the object. In the worse case, with a shiny object, the resulting reflection will cause lens flare and obscure the object altogether.

make a scene appear old-fashioned or nostalgic, while cooling down the colors can make a scene look sterile or ultra-modern. Also, think about enhancing the contrast between the foreground and the background by adding different colors to different areas in the scene. Remember that warmer colors tend to come forward, while cooler colors tend to recede visually.

Opt for Softboxes

You'll generally find softboxes more useful than umbrellas for still life images. It's easier to position softboxes above sets, aimed down, and they are less prone to spill light where you don't want it. In addition, when you shoot objects with reflective surfaces you can sometimes see the "spokes" of umbrellas reflected in the highlight areas, which doesn't look as natural as the large, even, and rectangular reflection of a softbox.

For many product images, an extra-large softbox placed directly overhead or slightly in front of a set up works well. This top-light setup means that the main light is coming from an angle perpendicular to the camera angle, so that even with a large softbox, the subject's texture still shows. Using a softbox that is as large as the set up itself ensures that the product or scene will be evenly lit, side to side and front to back. You can place your extra-large softbox over the set on a stout boom anchored to a heavy light stand, or you can just put two I-bolts in the ceiling

Most product shots begin with a softbox suspended over the top of the set.

and suspend your box with rope. Smaller boxes, used in the same position, can yield snappier light that falls off near the edges of your setup. The smallest boxes are very useful for creating exacting fill with soft shadows. These smaller boxes also can be more easily "barndoored" to control spill.

Adding Fill

With a basic top-light setup in place, all that is left to do is to fill in the areas that face the camera. We can do this using fill cards or little mirrors to bounce light from the softbox or bring in additional lights that are bounced into flat panels.

Things get trickier as the surfaces of the objects become more complex. Also, some objects, such as food, look better when lit at different angles. Let's look at some "real world" images and go through some of the basic lighting setups you'll want to consider.

Shooting a Product Against a White Background

Setting Up. If you need to shoot a product against a white background, you'll want a white background that can be used as a "sweep." This means that the en-

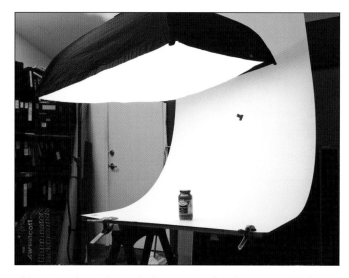

The image above shows the basic setup for shooting small objects on white. This piece of white formica has been lounging around the studio for at least a decade. One big light source from above is generally the best way to start. Once you've got your light source set up and the product in place, the next step is to meter at the product position and then again at the background to make sure your lighting is even. After we've got the top light set and the product positioned, I use black wrap to create small light subtractors that keep the sides of the glass jar from reflecting too much white and lowering the contrast between the edges of the jar and the background. This is seen in the top right photo. The final shot appears to the right. All of the photos in this sequence were shot with the Sony R1 digital camera.

tire background surface is one continuous piece with no defined horizon line. For most smaller objects, white formica or paper fills the bill—and you'll also want to work with a shooting table. Since my studio is small (and I usually photograph people rather than products), I keep on hand several tabletops that can be stored against a wall and a set of collapsible sawhorses. Using these, I can put up a workable shooting table in minutes (see page 18 for an image of this setup). Then, the top of the formica or paper can be attached to the top of a light stand using a large "A" clamp. The formica/paper extends down and curves out across the table, where the front edge can stabilized against the end of the shooting table using two additional "A" clamps.

Start with a Top Light. For most small objects, I start by adding a top light (usually a medium softbox). This keeps the sweep well lit and provides a good basis for overall exposure. Then, I add lights or reflectors as necessary.

A lot of this fine-tuning depends on the object you'll be lighting. Highly reflective subjects are much more difficult than matte-surfaced subjects, because a glossy surfaces reflect all the different light sources. When working with these subjects, you'll want to keep a bunch of black cards at hand to block reflections

from the surfaces that are visible to the camera. If front reflections become a problem, you may need to position the subject above and in front of the background, then put black in front and below it.

In the example on the facing page, using a spaghetti jar, I've angled the top light so that it also hits the front of the jar. There is no perfect way to light a curving, shiny object so there will always be a random reflection somewhere on the object. You can live with it (because these reflections occur in the real world), or you can use some Photoshop "elbow grease" and retouch the image to eliminate the problem.

Photographing Transparent Materials. Transparent materials are the most problematic of all photo subjects (with the possible exception of cranky, hungry models). Some still-life photographers specialize in shooting nothing but glassware, or (a sub-specialty) glassware with liquid pours. The secret to effectively dealing with subjects that are more or less invisible is to light them from behind and have strips of black on the sides to reflect onto the edges of the glass and provide a distinctive edge.

Using a Plexiglas Background. A good trick is to replace your usual formica or white paper background with a flexible sheet of frosted Plexiglas and push light through it to illuminate the subject. You can position lights under the Plexiglas as well as behind it. There are manufactured tables with specially curved Plexiglas tops, but using your sawhorses and a few pieces of lumber to support the edges of the Plexiglas you can easily make your own table at a big savings.

Before you use your milky-white Plexiglas sheet for the first time, however, you'll need to prepare the surface on one side. Huh? Yep. Plexiglas is very shiny on both sides and will show reflections from both the light and from any object placed on it. We prepare the surface by using very fine sheets of sand paper and carefully rubbing it in circles over one entire side of the sheet. This provides a matte surface that is surprisingly resistant to reflections. You don't need to be aggressive with the sand paper—you're only trying to remove the shine and nothing more.

When shooting objects on Plexiglas, I start by building a "table" (but with no top) to support an appropriately sized sheet of Plexiglas. Underneath the table, I put a white sheet (or other white reflective surface) right down on the floor. I'll

Transparent materials are the most problematic of all photo subjects . . .

I created a light table by putting a large piece of glass over a support of crossed boards on sawhorses. Then, I placed a red sheet of paper down near the floor. The distance from the subject to the red paper helped eliminate texture in the paper. I used one small softbox, close in to the bottom, and one fill card just out of the frame on the top. Any reflections of the fork on the glass were removed in Photoshop.

use this reflective surface to bounce light into, so the lighting for the Plexiglas surface will come from the bottom side of the Plexiglas. I set up two flash heads and illuminate the white floor covering as evenly as possible. This bounced light ensures that there are no hotspots or variations in tone on the actual shooting surface. Next, I place the object to be photographed on the Plexiglas and use several umbrellas or softboxes to provide a soft, even lighting on the subject from above or from the sides.

This is one of those situations where a light meter definitely comes in handy, as the surface of the Plexiglas must be as close as possible to ⅓ stop brighter than the light falling on the subject. If you're depending on the histogram on the back of your camera, you'll find that it's not easy to tell how much past white you've actually gone. If the surface of the Plexiglas is much more than 1 stop brighter than the subject, you run the risk of (A) light wrapping around the edge of your product and reducing contrast or (B) increasing your risk of flare ruining the crisp edges of your product. Once your digital camera hits pure white (or 255 in Photoshop-speak) there is no method for determining *how much* you are over.

An incident light meter will give you a very accurate indication of what the relative measures are. I take one reading with the dome facing up from the subject position and then one incident light meter reading with the dome facing down and touching the surface of the Plexiglas. I try to adjust the lighting so that the Plexiglas reading is ⅓ stop brighter than the light on the subject. An incident meter reading taken in the center and the corners of the Plexiglas (the corners that are visible to the camera) is also a good way to judge how even the bottom lighting is. The biggest obstacle to a great white Plexiglas background shot is the fact that your subject is resting on a surface that is parallel to the floor and already elevated to about three feet. You'll need some way of positioning and operating your camera from a position centered directly over the top of of the Plexiglas surface. This is where tethered shooting can become very handy.

Shooting Tethered. With the advent of digital cameras that can be tethered to a computer or a television screen, you don't actually need to be with your camera while it's working. We hook our shooting camera up to a laptop with a long cable and shoot with the control software that allows us to fire the camera, change exposures, and see the final product on a screen.

In most cases, we suspend the camera over the top of the subject using a regular set of background stands with a crossbar. The camera is attached to a stout Super Clamp which is then clamped in position on the crossbar assembly. My as-

This is one of my favorite product shots. 3M makes pipe sleeves that are applied and then shrunk with heat to form a waterproof barrier that prevent a wire corrosion. We created this set in the studio by putting a large sheet of white Plexiglas on a sawhorse/table frame and covering it with carefully prepared dirt. With the pipes in place, we lit from the top left and used no fill so we would have dark shadows to the lower right of each cable. The blue light that shows through comes from gel-covered lights set below the Plexiglas table.

sistant and I raise the the two background stands in unison and, through trial and error, find the right height and position for the camera. Once the camera is set, we can use the laptop to help us fine-tune the composition and bracket the exposure.

Before you protest that tethering software or an extra monitor is too pricey for the average Joe, let me quickly add that the first job I had to shoot directly overhead on Plexiglas required that I use a 4x5-inch, bellows-type view camera—with nothing automatic about it. I still remember using a number of clamps to fasten my heavy camera to a steel girder near the ceiling of my old studio—16 feet up in the air—and trying to focus the camera with a mirror, because there was no space for a human head between the ceiling and the camera back. It was a very long day.

By the end of the shoot, I was nearly cured of any acrophobia I might have had and my art director was knee deep in Polaroid test-film trash. We shot enough Polaroid during the course of the day to pay for three or four flat-screen monitors.

Single-Plate Food Shots

I shoot a lot of food for a magazine called *Tribeza*. All of it is done on location and I've come up with a nearly foolproof method of using small lights and portable diffusers to light these images. The same techniques work well in the studio, too. Here's the basic lighting setup that I use for single-plate food images.

LEFT—Shooting over a white Plexiglas table is a great effect that is not always able to be duplicated as effectively by compositing in Photoshop. **RIGHT**—*Once you complete a nice shot on white Plexiglas, you'll find yourself regularly returning to this technique when working for clients.*

First, I find an interesting background with a pleasing color. Then, I place the food on the back edge of a table or other piece of furniture so that when I shoot at an angle slightly higher than the plate I don't see very much of the table behind the plate.

Next, I light the background. Don't make lighting this harder than it needs to be. I generally use a small battery-operated Nikon flash at a reduced power setting with no diffusers or accessories. I want a wide spread that will cover the background and not cause any glare. The angle is unimportant. If you are shooting with the right lenses and have made sure to leave enough distance between your subject and the background, you'll be shooting so close to the main subject that the background should be mostly out of focus and unobtrusive.

Next, I get the camera as close to the entree as possible so that my main subject is filling the frame. I angle the plate up a bit and place the camera about six inches above the plate so I can "look in" on the entree. Use a "stand in" plate to do all of your composition and lighting adjustments, then add the real entree at the last minute. You should be shooting images within a minute of placing the food on the table. Any delays mean the product starts to dry out, juices start to run across the plate, and chaos settles in.

Crab cakes at Hudson's on the Bend in Austin, TX.

When your composition is locked, you're ready to finish your lighting. I usually position a round or square diffuser (either a pop-up or a Chimera frame) ninety degrees to one side of the main subject and as close in as I can get it. With some foods, lighting from slightly behind and above also works well. Once the diffuser is nestled in, I put a small light (usually a Nikon SB-800 if I'm on location) about five feet back from the diffuser and aim and zoom the reflector to provide an even light across its surface. The result is soft and directional light.

On the opposite side of the subject, I place a silvered reflector at a 45-degree angle to fill in and reinforce the overall lighting. I tend to use the diffuser closer with dark presentations and further away with lighter presentations; you can "season to taste."

Pescado Veracruzano at Fonda San Miguel.

Black Wrap

A quick way to make light blockers and barndoors is with "black wrap." This is heavy-duty, matte black aluminum foil that photographers and movie crews use for just about everything. You can mold it into a cylinder and tape it to your portable flash to make a quick snoot. Small pieces of the foil taped to the sides or the top and bottom of your flash work just like barndoors to block unwanted light spills, keeping your beam of light just where you wanted it. It's perfect for eliminating unwanted reflections in your still-life work as well as for subtracting fill light when used opposite your main light source.

I keep a roll of it in the studio at all times and usually have a few "used" squares tucked into the front pocket of my location roller case. I also keep a supply of old-fashioned, wooden clothespins on hand to attach the black wrap to the front reflectors of lights. (You'd be surprised how hot a modeling light can make a metal reflector—hot enough to melt tape and plastic clothespins.)

If your budget doesn't allow for genuine black wrap, you can always press regular, household aluminum foil into service. It doesn't hold its shape as well as the real thing, but that can be mitigated by using several layers. I don't advise painting conventional foil black; the paint will begin to smoke when heated and some paint could be flammable!

We use black wrap as lens shades, snoots, gobos, and anything else requiring a flexible opaque material.

Finally, if I'm feeling frisky, I'll add another small strobe way in the background to add a little bit of backlight on the subject. This gives a bit of separation and adds a sense of depth to the shot. The light should not be used at a high angle; I find it most believable if it comes from just a little over to the main-light side of the scene. This is a dangerous light, because with a mediocre lens there is always the danger of creating lens flare. You may need to use a little bit of black aluminum wrap (see sidebar to the left) to keep any light from striking your lens directly.

While I tend to use the Nikon CLS flash system for this work—because it's so convenient to control all three flashes from camera position with the SU-800 wireless controller—it's a technique that can work well with even the least expensive portable flash units and cheap, optical-slave triggers. The food doesn't care what brand of light is hitting it.

One important point when using any sort of dedicated flash control to shoot still-life images is that you should always choose the manual settings on the flash. Use the ability to ratio the lights manually. Why? Because if left in TTL or Auto, even the slightest shift in the camera position could change the automatic exposure and compromise your shot. The manual settings give you what every still-life photographer is looking for in his lighting tools: consistency!

Adding a Blue Glow

I thought you might be interested in the way we put together a typical still life shoot, so here's a case study in real time. My assignment for this job was to spend a month living with a newly released medium-format digital camera from Leaf Systems. Then, I had to evaluate it and review it for a photography magazine. I also needed to provide photographs of the camera itself, as well as examples of the camera's output.

In this tutorial, we'll just concern ourselves with photographing the camera as a product—a $44,000 product when the 180mm f/2.8 Schneider lens is attached! It's hardly the camera for a studio on a budget, but it was a lot of fun to play with for a little while.

I wanted to set up a classic "hero shot," and I also wanted to demonstrate the use of a background glow. This seemed like the perfect place to do both. When I say "hero shot," you probably know the kind of product shot I'm talking about: it has a dramatic background that spotlights the product. We see gleaming metal parts with smooth, graceful highlights, buttery midtones, and rich shadows that create a base for a sharp, crisp look.

The background glow is an important part of a certain genre of still life images and, even though you can put the effect together in Photoshop, it's good to know the nuts and bolts in case you get stuck in a studio on a desert island without Photoshop and need to deliver an image with a nice, organic blur to the local chieftain.

The first step is to set up the product and just look at it. Really look at it in order to get a sense of the proportion and the intention of the industrial designer and a feeling for how the product, in this case the camera, will look most alluring to a potential customer.

Once you've found its "best side" you've got to figure out what the subject will sit on. This determines how you will position it within the shot. In this case, I thought the most logical and best looking solution was to stick the camera on top of a beautiful, handmade wooden tripod from Germany.

The camera is highly technical and quite industrial in appearance, so I wanted to keep the background graphic, simple, and cool in color. The choice of background color came from research that suggests that cooler, bluer colors seem to recede while warmer colors seem to come forward. I chose blue, because I didn't want the background glow to distract from the product.

After you've made these basic choices, you should set up your product, find the camera angle that works the best, and set up the camera and taking lens. Once you've roughed in your composition you can move on to creating your background blur in order to anchor the composition into place.

Here's how you set up a background glow. Regardless of which color you ultimately, use it's best to start with black seamless paper. Starting with black as your "canvas" will ensure the most saturated and pure color glow you can get without resorting to computer post-production. Make sure the paper is far enough from the product/main subject so that the lights you use on the subject don't spill all the way back to your background. Spill light on the background desaturates the glow and turns your rich, black background into a muddy grey.

I want a tight circle of light for the glow on the background, so I'm going to use a grid spot on a flash head. We could do this with tungsten spots instead of flash, but I woke up feeling like using flash and that's usually how I decide which type of lights to use.

I select the grid that gives me the best circle of light. By that, I mean that it projects the right sized circle of light at a workable distance and angle to the background. In many cases, you won't be able to hide the "glow light" fixture di-

Starting with black as your "canvas" will ensure the most saturated and pure color glow . . .

rectly behind the product and you may need to place it lower or higher in order to keep the fixture out of the frame. I evaluate this by looking through the taking camera. It's pretty much impossible to know where the round spot of light will be in relationship to your subject by any other means. You can't stand over to one side and successfully position the glow so that it works for your camera's point of view.

The front face of the light will eventually be covered with a gel, but the blue gel that we've chosen for our glow really soaks up light, so we'll want to do our compositional fine-tuning with the gel off in order to more clearly see the final effect. If you need the glow to be slightly bigger or slightly smaller, it makes a lot more sense to move the light closer to or further away from the background rather than trying to select a "perfect" grid. Generally, studio photographers make due with three grids ranging from 30- to 10- degrees. Owning every permutation of grid angle would be ruinously expensive.

When you've locked down the position of the glow light source, you can go ahead and cover the front of the grid with the blue gel. I normally tape the gel on with gaffer's tape and, since the light shouldn't be moving, I turn off the modeling light to prevent the whole rig from heating up and burning through the gel filter.

Before I leave the background position, I meter the glow. The blue gel soaks up a lot of Watt-seconds, so I have the least flexibility to increase power to the background. I want to make sure that the exposure of the glow reads at least f/11 on my incident light meter when it is held against the seamless paper with the dome aimed back toward the camera position. The exposure for the background will affect all the other light settings. Fortunately, I use background lights fairly close to the background, so power is not usually an issue.

Now that the we have the background light set and metered and we've established the composition with the camera in place, we can move on to the next

Adding a blue filter to the background light.

LEFT—*Adding a softbox above the product.* RIGHT—*Here's what the top light does for our subject.*

part of the shot: actually lighting the camera. We start most product shots with an appropriately sized softbox positioned directly over the top of the product. This is the establishing light and illuminates the product from the most important angle.

Before you proceed, you should check to make sure that the light you added is not spilling onto the background. If it is, you can use a card or a gobo on a small stand to block the spill. You'll need to check through your lens to make sure that the card doesn't show in the frame.

Once the establishing light is set, and I've made sure we're not de-grading the purity of the background glow, I look at the product again and try to decide which areas need more light and how to deal with them. In this example, I decided I need more light from camera right. I added a medium-sized soft-box with a monolight set to its minimum power. It was still too powerful, so I added some black net over the front of the softbox in order to drop the power down by about two stops.

At this point, I felt like I was in the ballpark, so I decided to fine-tune the lighting by bringing up some of the dark areas using white boards as reflectors. I used one white board to the front and underneath the camera to add more tone to the shadow areas. I used a second white card near the lens to put a nice re-flection into the lens, which adds a bit of depth and shows the glass.

The final shot is shown below. I'm showing you a raw image, but the final se-lected image would be retouched in our studio (or sent to a retoucher) to take out any imperfections in the product and to smooth out the tones on the metal surfaces.

LEFT—*Now we add a softbox to the right-hand side of the setup. Check to be sure that the light from the above doesn't spill onto the background and degrade the quality of your blue spot.* **RIGHT**—*We've added in two white cards to put more light onto shaded parts of the camera and used some screen material over our righthand softbox to cut down on its light output.*

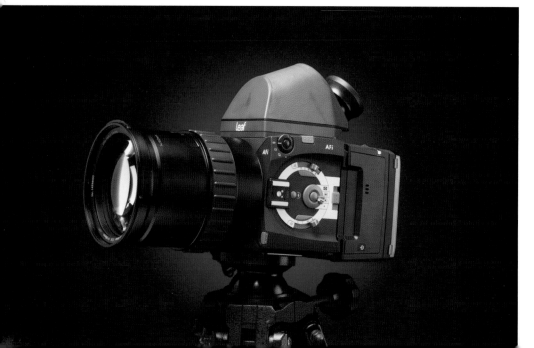

Here's our finished Leaf camera "hero shot" with a nice blue glow.

Another Demo: The Wine Bottle

I was always afraid to light wine bottles and glasses until I learned a valuable technique from a photographer named Charlie Guerrero. Charlie showed me how to cheat and light a bottle or a beer mug against a dark background and also against a white background. Here's how we do it:

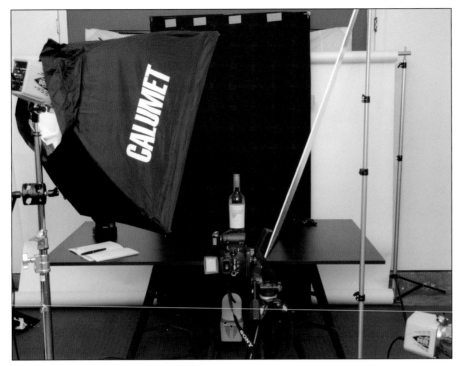

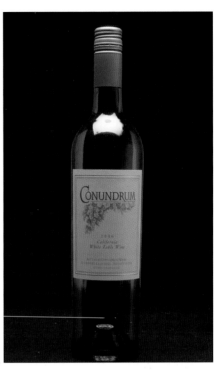

We try a softbox to the front and one side. This doesn't work, even when we add a foamcore fill card to the other side.

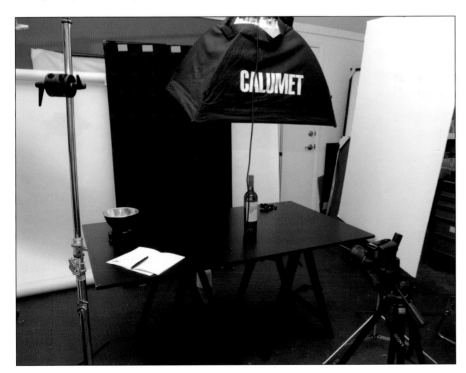

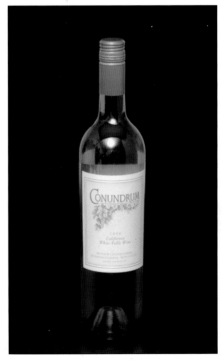

Unfortunately, our standard "over the top" lighting setup results in no big change from the front-light version.

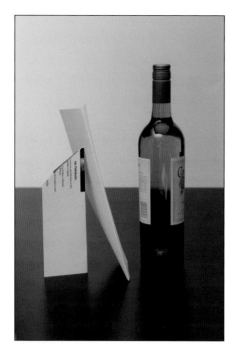 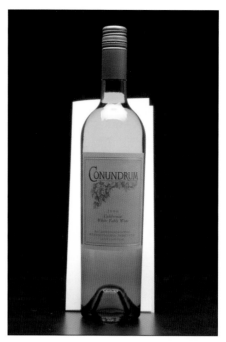 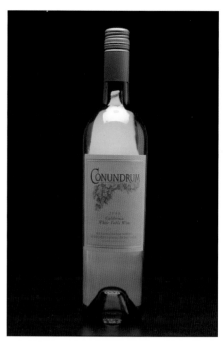

LEFT—*We can actually make the dark background work if we spend a little time making a custom reflector to use right behind the bottle.* **CENTER**—*Here's what it looks like with the white card dropped behind the bottle. It uses the top light as a source.* **RIGHT**—*Here's what the image looks like with the custom-cut card.*

 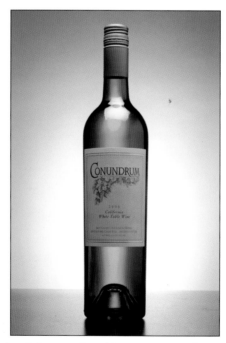

LEFT—*Suppose we ditch the black background and throw a nice white spot on our white seamless background? Kinda like this.* **CENTER**—*We get something that looks like this. Not bad . . . but we could use a bit more light on the logo.* **RIGHT**—*Instead of trying to add another light to our setup, let's use a mirror to bounce some light onto the label. Here's what the mirror setup looks like from the back. Notice the slice of black wrap across the bottom of the mirror to keep a big reflection out of the bottom of the bottle.*

Some General Rules of Thumb for Lighting Still-Life Images

It's Not About the Lighting. Remember that your shot is about the product. Not about the lighting. The lighting design exists to showcase the product.

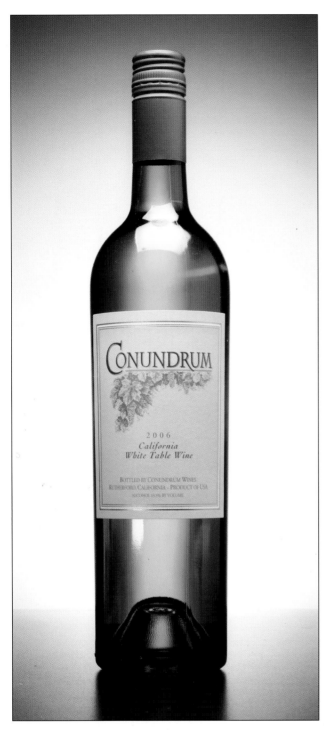

And when we put it all together it looks like this!

Lay a Good Foundation. Before you set up any lights, lock down your basic composition and figure out what you want to do with the background. The proper selection of a background and its relationship to the main subject of an image is one of the most important steps and will make or break your shot.

Evaluate the Needed Depth of Field. Once you've got your composition figured out, the next step is to figure out how much depth of field you'll need to achieve sharp focus where you want it and soft focus where you want it. A product shot of a computer system for a catalog might demand sharpness from the front of the keyboard to the back of the casing, which may require an aperture of f/11 or f/16. (Note, however, that too small of an aperture on a small-format camera may actually cause a your images to become *less* sharp because of the effects of diffraction. This is why the use of f/16 or smaller is not recommended for APS-sized digital cameras.) A food photograph may work better with very shallow depth of field, allowing you to showcase just one part of the scene while diminishing distractions by putting them out of sharp focus. In these cases, you'll want apertures of f/2.8 to f/5.6.

If you are unable to see the effects of your selected aperture adequately on the rear screen of your camera, you might want to transfer the image to your computer and look at it carefully on the screen. Lack of depth of field usually only becomes apparent when an image is blown up. You've got time to check; your subject isn't going anywhere!

Light the Background First. As you begin to set up lights, try to light your background first (we'll talk more about backgrounds in the next chapter). You'll already know the brightness range you'll need if you've decided what aperture you'll need to shoot at. The background lighting will serve to anchor the other lights you'll add.

When you are shooting transparent objects, remember that you are really lighting the background behind them. You'll use lights or light blockers to give transparent objects a defined edge.

Add the Main Light. The next step is to add your main light. Think about the logic of its direction. A side light helps to show depth and texture. A top light is more even, but can be boring. Too hard a light causes dark, hard shadows that obscures detail in areas not directly touched by the light. Too soft a light can reduce the contrast of a scene and its apparent sharpness.

Once your main light is set and you've looked through the lens of your taking camera to ensure that there are no spurious reflections or hot spots, you can

start tweaking the main light using light blockers to subtly subtract light from areas that are too bright (perhaps too close to the main light).

Add Any Needed Fill. Once the composition, background light, and main light are set, all that's left to do is decide whether or not you need to add fill light and, if so, how you want to handle the fill. You could choose to use large reflector sources for a soft even fill, or a number of smaller reflectors (or mirrors) to add a more selective sets of multiple fills. Of course, there is always the old standby: a second large light source near the camera position set at a level that give an exposure about two stops less than the main light.

Keep it Simple. To keep from creating chaos in your scene, try to limit your lights to just the minimum number of fixtures necessary to make the image work. Too many lights add extra reflections and conflicting shadows. Use passive reflector boards whenever possible. A side benefit? They're cheap.

Some Final Thoughts

This book could be thousands of pages long and not begin to cover all the variations of lighting possibilities for still-life images. So many of the decisions you make are predicated on the products or objects themselves. Are they larger than a breadbox? Smaller than a dime? Shiny or dull surfaced? Solid or liquid? Most of the time, your still-life subject will be a combination of all these factors at once. Fear not. With practice and logic, your mastery of still-life photography will happen. Eventually.

Taken as a test for for Agfa Corp., this shot incorporates our blue background glow and one soft light directly over the bowl.

This was a pretty standard studio shot for Texas Gas Services (art director: Greg Barton). I lit the roll of insulation using one large softbox to the right side of the camera and filled on the left side with a large white panel. We created a money return using metal bars that were retouched. The cash return was added in Photoshop.

7. Up Against the Wall

Choose Your Background

No discussion of studio lighting would be complete without discussing backgrounds. If you want to tackle a wide range of subjects you'll probably need a fair number of backgrounds.

Seamless Paper

We routinely keep 9-foot-wide rolls of seamless paper in white, medium gray, and black on hand. The medium gray paper can be lit to make it a shade or two lighter, or, by blocking light from hitting it, a shade or two darker. To make your seamless paper last a long time always store it upright so that the roll is perpendicular to the floor. This keeps the paper from getting out of round and showing ridges when it is rolled out.

Seamless Does Double Duty. White is the most used seamless paper in most studios, but it can also do double duty as a large reflector when nothing else is at

We routinely keep rolls of seamless paper in white, medium gray, and black on hand.

This shot was used to market a Zachary Scott Theater production. It was lit using a 4x6-foot softbox to the left of the camera. This was covered with several additional layers of white diffusion cloth. Two gridded lights, covered with colored gels, illuminated the background. A white wall ten feet to the right of the women provided fill.

hand. Black is our least used background, but it comes in handy when we need to block out daylight for various effects.

Colorizing with Gels. In many still-life situations the background will be thrown out of focus and appears only as a shade or color. Some studios keep many different colors of background paper in stock, but I find that using color filter gels over my background lights is a quick and easy way to get various colors (an example of this technique appears in the previous chapter), and the filters seem sturdier and less expensive than rolls of paper. The fewer large objects I need to store in the studio, the less cluttered it seems—and the more space I have in which to create.

This portrait of Joseph Reitman (left) was photographed for a magazine article about the film industry in Texas. Note the gold background, which is really a bolt of cloth from Walmart's bargain table. Tom Fontana (right), the creator and writer of the HBO television series Oz, was also photographed in front of the same material.

Muslin and Canvas

As I've said before, I love to do portraits. Because of this, I'm always on the hunt for great organic backgrounds. I search out various warm gray backgrounds and also have a weakness for rich warm browns. I'm a sucker for muslin and canvas backgrounds. Muslins are easy to set up, easy to store, and are generally a third the price of canvas backgrounds. I always suggest getting the largest size you anticipate using.

Most large muslins are sized to 10x20 feet or 10x24 feet. A background of this size enables you to hang it from the crossbar of a background stand system, put the top edge of the background at eight or nine feet high, and still have twelve to fifteen feet of material to drape forward on the floor toward the camera. This allows you to use a higher camera angle and get more side-to-side image without seeing the top of the background.

Custom Designs

Over the years, I've made a lot of my own backgrounds using muslin from furniture stores that supply upholstery businesses. We dye them in a tub in the backyard and dry them on the fence.

I also stop by discount fabric stores from time to time and look through all the different bolts of cloth they are getting rid of. I've found some incredible colors and textures for prices as cheap as one dollar per yard—and I've used them for some really fun projects. I did one project for a magazine that called for shooting movie actors, writers, and directors against a rich, golden background. I looked at seamless paper, but the art director wanted the dimensionality of fabric with its distinct folds and gathers. I had a bit of time so I started looking everywhere.

At one point during my search I was down in San Antonio doing an unrelated assignment for a manufacturer of uninterruptible power supplies. I had arrived at the location half an hour early—and had forgotten my cell phone. The closest business was an older Walmart, so I went in to find a pay phone and, since I was early, I decided to walk through the store and try to understand the Walmart appeal. During my leisurely exploration, I stumbled across their fabric department. There on the remnants table was a bolt of the perfect gold cloth, and it was on sale for a dollar a yard! Of course, it was polyester and up close it exuded "tacky," but used as a slightly out-of-focus background, it was just what the art director ordered. I bought the bolt and couldn't wait to get back to the studio and test my find. It was perfect—absolutely perfect—and the entire ten yards cost a paltry ten bucks. That was the Walmart appeal.

We used the golden polyester for two full days and the images ran on a number of pages in the magazine. The bottom line is that using traditional photo-store backgrounds would have worked, but our "re-purposed" bargain cloth worked even better at less than a quarter of the price.

In the same vein, we've used brown butcher paper, rusted sheet metal, bright blue tarps, ripped-up cardboard boxes, and many other impromptu backgrounds that created a unique look and feel without spending a fortune. Other photographers (who are better craftsmen than me) swear by using painter's canvas and oil paints to get just the background they always wanted. Hardware stores are also a great source of canvas backgrounds, which the stores call "painter's drops," as well as the white formica you'll want for shooting small products.

The bottom line? If you like it, use it—and never underestimate the importance of a good background. I'll reiterate something I've mentioned before: I al-

If you like it, use it—and never underestimate the importance of a good background.

ways decide on (and light) the background first. Only then do I put together the rest of my shot. If the background doesn't, work the shot doesn't work—no matter how great the rest of your lighting design is.

LEFT—*A good white background beats doing clipping paths every day of the week.* **RIGHT**—*Some clients request portraits against a white background because they anticipate multiple uses with several different backgrounds.*

Portraits Against A White Background: Step-by-Step

I get more queries about shooting people against a white out background than about anything else. I'll show you the way I do it—but keep in mind that there are dozens of variations to this technique and some parameters will change with the size of your studio.

Prepare the Seamless. Start with a white seamless paper. Sweep it out at least ten feet into the room and tape or anchor it to your floor.

Then, place a shiny piece of formica on the floor for full-length shots. The formica picks up the light bouncing from the backdrop and the specular highlight this causes makes the surface go totally white when you shoot. It also gives the subject a "mark" to stand on, while saving wear and tear on the paper.

Light the Background. Evenly light the background. Umbrellas definitely make it easy to get a nice, even spread of light across the background (but always use black-backed umbrella to prevent any light from spilling forward). You can substitute small softboxes for the umbrellas, but the umbrellas are more even, more efficient, and much less expensive. I use four lights on the background when I'm shooting a full-length portrait. Aim each umbrella toward the far edge of the background (the left umbrellas will be aimed at the right edge of the background

and vice versa). This "feathers" the light and will help ensure a smooth spread of light. Using an incident light meter, I try to make every part of the background that will show in the image measure within ¼ stop. This creates a perfectly even background.

Frame the Subject. Using large, black panels, "frame" your subject with black panels placed behind them. Set these up so that the edges of the black panels nearly, but not quite, touch the edges of your subject. This will reduce lens flare and eliminate any light bouncing from the background onto the subject. It will also provide a nice edge on the outside contours of your subject. If you've done it correctly, it will always be easy to add more white area around the subject in postproduction.

Add the Front Light. Now, front light your subject and set your lights so that the background lights are ⅓ stop hotter (higher in measured intensity) than those on your subject. If the background is too hot (bright) the reflected light will wrap around your subject and reduce contrast to the point that there is no definable subject edge. If the background light is too low, you'll get a muddy background with texture that needs to be clipped or masked in postproduction, adding time to your project and reducing the natural look of a white-out background.

Shade Your Lens. Now you're ready to shoot—and the image will look at lot more natural than trying to cut your subject out of a background using software. If you want the very best results, be sure to shade your lens as rigorously as possible. I use a compendium shade and cut strips of black wrap in order to "flag off" the light, preventing any spill light from hitting the lens. Always use the longest lens you can, given the size of your studio. The longer the lens, the less surface area of the background is shown. This is very helpful in keeping the background evenly lit.

A "Dramatic" Case Study

While writing the above description, I got a phone call from a marketing director at a local non-profit group who asked me to do a series of photographs against white with five actors. This would be used to market their production of the musical *Altar Boys*. We used a large studio at the theater and went through the process of setting up the lights and the background. I thought I'd share this example to show that my above description is a best-case scenario. All setups are fluid and subject to change.

Here's the setup. The camera distorts relative sizes and distances, so rather than just looking at the photos, let me talk you through the shoot.

It was Saturday morning and I met my assistants, Will and Amy, at Zachary Scott Theater. We'd been asked to do a series of images of the five actors who would star in *Altar Boys*. The art director requested that all the images be shot against a white background, because several of layouts would later have different backgrounds and graphic treatments dropped in. We needed to set up a wide roll of seamless in order to fit all the actors in. We also needed a lot of depth in our makeshift studio so I could use a longer lens. A long lens used further from the

We needed to set up a wide roll of seamless in order to fit all the actors in.

background helps to hide the edges of the background. Use a shorter lens and you may have trouble with the edges of the background intruding.

Will and Amy got to work on setting up a roll of 9-foot wide, bright-white seamless paper against one wall, while I set up the camera and lens we'd be using. They pulled the paper out about twelve feet into the room to create a sweep with no horizon line. When the paper was rolled out correctly, they used an "A" clamp to attach the roll to the crossbar so that the paper didn't continue to spool out. The front of the paper was taped down with white gaffer's tape so that the slight roll of the paper didn't obscure people's shoes. Once the background was in place and secured, we got on with the job of lighting.

We used the four black umbrellas to light the background. In this instance, Amy measured the light falling on the paper with an incident light meter, every few feet from side to side, and found it to be within 1/10 stop!

I had recently fallen in love with the quality of light from the 80-inch Lastolite umbrella, so I decided to use it again. I set the umbrella up in a very counterintuitive way, though. Rather than use it close in, to emphasize its softness, I used it at least twenty-

We always start with the background. This is a view from the background.

From the camera position, you can see all four of the black-covered umbrellas aimed into the white seamless—as well as the large silver reflector to the right.

five feet away from the subjects and approximately 30 degrees from my camera position. I placed it up as high as I could get it and I put a lot of power into it with one head connected to a Profoto Acute 1200Ws pack. This gave me both a soft light that would cover the actors evenly and also (because of its distance to the actors) it gave me light with a sense of direction.

I placed a silver reflector on the opposite side of the boys to bounce some fill into the right side of the set up and we started shooting. I wasn't accustomed to using the Profoto 1200Ws unit at full power and kept shooting before the recycle indicator beeped. Will gently reminded me that if I turned the box down to half power and turned up the ISO on the camera I would have a much faster recycle time. It worked.

An hour after the setup, we did what photographers dread most: we took everything back down, repacked all the gear, and cleaned up. Next stop? Chuy's for Tex Mex food. This is Austin, after all.

All of our main lighting for this image came from the 80-inch umbrella. This shot of the setup was taken from the camera position.

After the setup and fine-tuning were done, we actually got to shoot!

8. Additional Tips for Studio Photographers

Magnifying Your Studio

If you are like most of us, your studio has fairly limited space. Here are some things you can do to make it feel a bit bigger.

Get Rid of Clutter. The more small things there are around the edges of your space, the smaller the room will feel. If you must keep lots of items in the studio, invest in some white cabinets with doors and hide the clutter away. (I should really take my own advice.)

Stick with White. While painting your ceiling and walls black or gray may help you deal with light spill and its attendant contrast degradation, black ceilings and walls make a space feel much smaller than it really it. A black interior creates a space that is dark and will not be comfortable or appealing to most potential clients. It will, however, make a great meeting place for a Goth book club. Keep the space white and use black panels to control light spill.

Use Light Blockers. In a smaller studio, you'll probably need to shoot with the subject closer to the background than you might like. This means you'll really want to make use of large, light-blocking panels to control the reflections off a lit background. Don't be afraid to use them close in to the subjects, especially if you are shooting against a white background.

Get Some Elevation. If you are shooting groups of people, you will want to invest in a sturdy step stool so that you can shoot from slightly above. It's always easier to roll out more of a seamless background on the floor than it is to extend the background up further–especially if you have a short ceiling height. The same goes for muslin backgrounds. Getting up higher and shooting at a slight downward angle allows you to photograph taller subjects without seeing the top edge of your background. The "gold standard" step stools are the ones that can roll around on the floor, but when you step down on them the little wheels retract and the wide base anchors you to the floor for maximum safety.

Choose the Right Lens. You might think you can rely on shorter lenses, and to a point you can. A shorter lens will always show more of the background behind the subject, so you'll need to deal with that by either making sure your light covers the whole background or by moving the subject closer to the background and using a longer focal length. There will be compromises, but that's part of the challenge.

One high-quality zoom lens beats several sexy prime lenses in a smaller studio, because you can zoom right down to the optimum magnification for your subject without a lot of waste around the edges of your frame. When shooting against

This is a must-have piece of furniture: a safe step stool to stand on (and even to pose people on).

white, I try to tighten up my composition as much as I can to keep from dealing with flare. If I've done my lighting correctly, I can always add more white area around the subject in postproduction. My current favorite lens on a cropped-format digital camera is the Nikon 24–70mm lens. It seems custom made for studio work.

If you love to shoot still-life images, you'll want to make sure that you've got a selection of macro lenses that maintain their high quality as the camera-to-subject distance shrinks. Although not widely discussed, most lenses are optimized to perform well at the camera-to-subject distances preferred by the demographic that most uses the lens. In most cases, for instance, long zooms are optimized for best sharpness at a camera-to-subject distance of over twenty feet to infinity. Most of the multi-purpose, mid-range zoom lenses are made to per-

Writer and financial analyst, Lou Lofton, was photographed using one of my favorite setups. To the left of the camera, I placed a 6x6-foot diffusion screen as close to Lou as I could without having it appear in the frame. Two feet behind the screen is a 40x60-inch softbox on a Profoto monolight. Five feet to the opposite side of Lou is a 3x6-foot piece of foamcore as a fill source. The background is illuminated by spill from the main light.

form well from about six feet to around thirty feet—meaning they are definitely *not* optimized for rigorous sharpness at the kind of close distances you might encounter frequently in the studio when shooting still-life images. My two most used studio lenses for still-life shots are the new Nikon 60mm AFS Macro lens and its sibling, the 105mm VR Macro lens. Both generate incredibly sharp images all the way to life-size magnifications.

Getting the Studio Ready for Business (or Personal) Projects

Before you do your first shoot, make sure you've got a plan in place for success. This would include removing anything that may be dangerous to someone coming onto your property. Tie up the attack dogs, fill in the potholes, and make sure there are no other hazards. Your studio should be freshly painted, as that will also allow you to feel like you are working on a clean canvas. If you are photographing people, they will need some privacy in which to change clothes, as well as a nearby bathroom for calls of nature.

Finally, organize all of your equipment so that the special lens or light modifier you need is at hand when you need it. In the long run, you'll be more efficient, effective, and successful.

Temporal Quicksand (Or, "I Can Fix it Later in Photoshop.")

The odious utterance above is made by many who've never had to go back and take something out of a photograph without leaving evidence of a big gap. Or by people who've never had to put a person or object into a photograph without leaving any traces. It's easy to be a Photoshop expert—and there are a thousand ways to do things—but one thing is pretty much assured: if you don't spend the five minutes to fix a problem while you're shooting, you'll spend five hours trying to fix it in postproduction.

Take the addition of a person to a group shot. It seems easy to the client—"Just take Agnes from this vacation picture at the beach and drop her in next to Bob in the group shot that we did in the conference room." Some clients assume there is a magic filter or button for every step. But when you find out that the final image will be used on a poster, things start to get a bit hairier.

First of all, the lighting on the beach and the lighting in the conference room just don't match. The beach light is harsh and unidirectional. The group shot is evenly lit with softboxes. The color cast of the images

We created this desert scene in the studio with a couple bags of sand. A light from the back of the set, with a gel to provide a warmer color balance, was used low to show the ripples and texture of the sand. A small softlight filled the front of the product. In the shadows, just in front of the product, we used a flashlight covered with a red filter to "paint with light" and add a red glow.

While not strictly a studio shot, this is a great example of using gels over lights to create effects. When lighting scenes with monitors, it's important to keep light off the screens. When this is unavoidable, you can mask the screen off with black felt and do a double exposure, one shot for the overall lighting and one shot just for the screen.

is different and they were probably shot with two different cameras—maybe a film disposable and a professional, high-resolution digital camera. The photo of Agnes is not sharp, while everyone in the group is razor sharp. Even if you can figure your way around these hurdles, you'll be confronted with the need to meticulously trace the outline of Agnes, in hundreds of points, in order to pull her out of the photograph with smooth enough edges to be placed into another image. The list goes on and on.

With this in mind, I try to be careful to wipe fingerprints off the surfaces of products that will be photographed. I know that one minute with a rag and some cleaner will save me at least twenty to thirty minutes with the clone tool in Photoshop. I try to make sure that background color glows are the right size and shape when I shoot them, because I know I'll have to peel my images apart into layers and create a custom digital glow if I don't.

If time is money—and it is in the studio—then fixing all the parts of an image before you commit it to the sensor just makes financial good sense. It's true that retouchers can fix just about anything, but the good ones charge upwards of $250 an hour and some jobs take days! It's interesting math—and something to talk about the next time an art director tells you, "We can fix that in Photoshop." When I hear this, the first thing I ask is, "What file format do you need in order for *you* to work on that?"

Control Your Spending and Stay in Business

The biggest mistake I see photographers make is buying way too much equipment way too soon. I firmly believe that the majority of jobs we do as image makers can be handled with three good lights and a handful of modifiers and accessories. While it's true that several times a year you may land a fabulous project that requires a lot more lights, you'd be foolish to use these temporary needs as an excuse to go ahead and buy new stuff. You'll just end up sacrificing your own profit and you'll end up with more stuff to store, service, and think about.

When we bid a large job that may require us to light several large sets concurrently, we quickly turn to our fellow local photographers and arrange to rent—not borrow—the extra lights we need from them. If the lights or gear we need aren't available from our peers, we turn to the rental houses for the additional gear, and we always make sure that the extra gear can be billed back to the client.

My rule of thumb is that if you need to rent something more than five or six times a year, then it make sense to buy it and put it into inventory. Otherwise, it constitutes a specialized tool that the client needs to pay rent for.

We should look at ourselves as problem solvers. When we bill a client, it should be for the usage of our images and for the profundity of our ideas, not how many cool toys we can bring to the game. There will always be someone with newer, shinier, and more expensive toys; creative ability will make more of a difference in the long run.

You always have a choice when the checks for the big jobs roll in: buy more gear or put it in the bank. If you buy this year's latest gear, you'll kick yourself when the economy hits a little bump next year.

These images of Michelle Rodgers were photographed on black & white film using a 500W tungsten light pointed into a 60-inch umbrella, which was diffused by a shower curtain. One small spotlight was used on the background. My reason for using continuous light was to be able to set a wide-open aperture on a medium telephoto lens on a medium-format camera body, ensuring a very narrow depth of field.

The Wrap-Up

Throughout this book I've shown you basic gear and basic lighting ideas. My photos are representative of the way I see light and compositions. My hope is that you'll take the information we've covered and apply the theories and practical suggestions to create your own style of lighting and photography—designing images that correspond to your vision rather than trying to recreate the setups you've found here.

It's always been my opinion that the ability to light a person or a still life well is a key to becoming a more fully functional and creative photographer. With today's cameras, just about anyone can compose, expose, and produce a well-focused and well-crafted available-light image. It's the ability to create beautiful lighting from the fixtures and materials you've selected that separates the snapshooters from the artists and professionals.

This is my favorite food shot—not because of the lighting, but because the onion rings look so tasty!

Learning about lighting is a vast undertaking of which this book is merely one small step. In the following resources, section you'll find lots of other venues from which you can expand the depth of topics we've touched upon here as well find new and unique information that will inform your search for the ultimate in illumination.

I have been a photographer for over twenty-five years and I still discover new ways to light and new instruments to light with. In the coming years, advances in lighting and imaging technology promise to further expand our abilities. For example, LED (light emitting diode), with its color purity, lack of heat, and high efficiency, is likely to push out tungsten and fluorescent lights as sensible choices for photographers. As this technology evolves, you can expect to see precise color-temperature controls that eliminate the need for filters and the introduction of portable panels that will fit in your camera's hot shoe. Also on the horizon are

digital cameras that can shoot grainlessly at ISOs starting around 3200 and heading up past 12,000. This will have profound ramifications for lighting manufacturers, as lower and lower levels of light will be required to create styles that previously high-power sources.

Even with all these changes, though, the bottom line will stay the same. The photographers who will remain in demand will be the ones who can establish a good rapport with their sitters and models, find unique perspectives and lighting styles for both living and inanimate subjects, and create a visual narrative that delights people. The new tools are just that: tools. Those who have developed unique styles with their current tools will be positioned to quickly leverage the latest inventions.

These new discoveries don't compel me to change the basic style in which I shoot. They don't radically transform my vision, because I've found a way to look at people and products that makes sense and is pleasing to me. What the new tools do is to help me refine my look while making the process easier and more fun.

Photography will always be a rich field for creative people. I hope your journey into lighting brings you great happiness and fulfillment!

This was shot in the same fashion as our onion rings, with background glow and top light, but I added a white card at an angle directly behind the jar of oil to reflect light through the liquid.

Kirk Tuck
Austin, TX

Resources

Web Sites

There are millions and millions of web sites out on the internet and it seems like half of them have to do with photography in one form or another. Any list of web resources is incomplete so this one will have just the web sites I like to frequent to learn more about lighting.

www.strobist.blogspot.com. This is the preeminent web site for lighting with small flash units. The site was created and is written by photographer, David Hobby. Start with "Lighting 101" and go from there. You will learn a tremendous amount about lighting in general and portable lighting in particular.

www.photo.net. One of the largest and oldest photographic web sites on the Internet, this is a treasure trove of information with reviews, forums, and articles that will suck up hours and hours of your time. (Of course, my favorite article is one about the Leica M6 written back in 2001 . . .)

http://theonlinephotographer.com. While not exactly a site about lighting, long-time photographic writer Michael Johnston is doing his best to maintain an intellectual rigor in understanding photography. His site is a rich and eclectic mix of camera reviews, book reviews, rants about modern culture, and introductions to interesting photographers doing interesting work.

www.prophotoresources.com. This site features monthly columns about photography, lighting, and marketing by over a dozen successful and well-known photographers. Usually, there is a mix of inspiration and "how to." It represents what is going on, visually, in the commercial markets, month by month.

www.kirktuck.com. I have a web site with a wealth of articles about lighting and shooting actual jobs that is a resource for many of the techniques I've found useful during my career as a commercial photographer.

Magazines

In the age of the Internet, I still find actual printed magazines to be a wonderful, tactile source of information and inspiration. The magazines I list below are specific to the photography industry, but if your interest is in lighting and photographing people, you'll also want to look at the fashion magazines, such as *Vogue, Elle, V,* and others, to see what people with enormous budgets and access to the world's finest models are up to. For photo magazines, the ones listed below are the ones I read on a regular basis.

American Photographer. A great blend of profiles about photographers, industry trends, and interesting products that have a wide appeal. Even though it

has been "dumbed down" since its launch decades ago, it is still a fun read and helps one to stay current with mainstream photography.

Photo District News (PDN). This is the current "top of the heap" of magazines aimed at professionals, semi-pros, and amateurs who one day aspire to professional status. The front part of the magazine is usually a calendar of photographic events and shows across the country. Next is their "newswire" section, where they discuss who's doing what and for whom. They showcase really cool advertising campaigns by the superstars of the industry, and they also cover big trends. To be profiled in *PDN* is to have "made it" in the business. If you are a commercial pro and you are not reading this magazine every month, you are effectively out of the loop.

Professional Photographer. This magazine is aimed at the wedding, portrait, and commercial photographers who are members of the Professional Photographers of America (PPA). Its articles span a wide range of photo interests with an emphasis on working photographers who are running successful businesses in cities and towns across the country.

Rangefinder Magazine. In many ways, this magazine goes to the same market as *Professional Photographer*, but the articles are more esoteric and wide ranging. A recent issue, for example, covered landscape photography in depth and did a good job of exploring the rich variety of work being done across the country. The writing is good and the technical articles are "chewy" enough to really satisfy.

Good Books

I'm a sucker for good books. I've learned 90 percent of the knowledge I've used to run a successful business from a long list of books I've picked up over the years. There are some that are useful in the moment and some that stand the test of time. The ones listed below are the ones I come back to again and again for reference and inspiration.

Matters of Light and Depth: Creating Memorable Images for Video, Film, and Stills Through Lighting (Ross Lowell; Lower Light Management, 1999). Lowell was one of America's finest directors of photography in the movie industry before starting the famous lighting company which bears his name. The book is more theory than "nuts and bolts," and as such the information is timeless and applicable to the styles from any era.

The War of Art: Break Through the Blocks and Win Your Inner Creative Battle (Steven Pressfield; Grand Central Publishing, 2003). An amazing book aimed at inspiring artists in all fields to get to work and do their dreams. I give out one of these to a tired, dispirited photographer at least once a month—and weeks later, when I see the person again, they are transformed, energized, and excited to be working.

Photoshop Restoration and Retouching (Katrin Eismann; New Riders Press, 2006). This book is widely regarded as one of the best guides to basic electronic retouching of both product and people by a renowned lecturer on the subject. It's

got indispensable information on color correction techniques as well as a great chapter on portrait retouching.

Photography: Focus on Profit (*Tom Zimberoff; Allworth Press, 2002*). Warning: There are no photos in this book, but it is jammed full of very important information about making your business profitable. Tom is a no-nonsense writer who fills the pages with information won from decades of being in the business—successfully. I keep a copy next to my desk and I refer to it when I need more back bone to raise prices or do a tough negotiation with a potential client.

Your Local Camera Stores

When I first started taking photographs, everyone had their favorite local camera store and, drilling down a bit more, their favorite camera salesmen. In those days, one cultivated a relationship with their salesperson, which paid off with prompt deliveries, information about new and old products, and the best pricing they could deliver. At one point, I thought the web would destroy all the local photography merchants and that our only recourse would be shopping on the web. I am happy to report that good local, independent shops are still out there—and indeed, some are thriving! My favorite camera store is Precision Camera and Video, right here in Austin, TX. They stock a wide range of great stuff and can special order just about anything I would want. They've saved more than one job with a quick delivery of a crucial piece of equipment and they've always gotten me the latest products quickly. If there's a waiting list, I'm usually at the top of it! Funny thing is, on most of their products they are competitive with the dealers from New York.

Index

OTHER BOOKS FROM

Amherst Media®

MINIMALIST LIGHTING
PROFESSIONAL TECHNIQUES FOR LOCATION PHOTOGRAPHY

Kirk Tuck

Use small, computerized, battery-operated flash units and lightweight accessories to get the top-quality results you want on location! $34.95 list, 8.5x11, 128p, 175 color images and diagrams, index, order no. 1860.

PROFESSIONAL PORTRAIT POSING
TECHNIQUES AND IMAGES FROM MASTER PHOTOGRAPHERS

Michelle Perkins

Learn how master photographers pose subjects to create unforgettable images. $34.95 list, 8.5x11, 128p, 175 color images, index, order no. 2002.

DIGITAL PHOTOGRAPHY BOOT CAMP, 2nd Ed.

Kevin Kubota

This popular book based on Kevin Kubota's sell-out workshop series is now fully updated with techniques for Adobe Photoshop and Lightroom. It's a down-and-dirty, step-by-step course for professionals! $34.95 list, 8.5x11, 128p, 220 color images, index, order no. 1873.

MASTER LIGHTING GUIDE
FOR COMMERCIAL PHOTOGRAPHERS

Robert Morrissey

Use the tools and techniques pros rely on to land corporate clients. Includes diagrams, images, and techniques for a failsafe approach for shots that sell. $34.95 list, 8.5x11, 128p, 110 color photos, 125 diagrams, index, order no. 1833.

PROFESSIONAL PORTRAIT LIGHTING
TECHNIQUES AND IMAGES FROM MASTER PHOTOGRAPHERS

Michelle Perkins

Get a behind-the-scenes look at the lighting techniques employed by the world's top portrait photographers. $34.95 list, 8.5x11, 128p, 200 color photos, index, order no. 2000.

SCULPTING WITH LIGHT

Allison Earnest

Learn how to design the lighting effect that will best flatter your subject. Studio and location lighting setups are covered in detail with an assortment of helpful variations provided for each shot. $34.95 list, 8.5x11, 128p, 175 color images, diagrams, index, order no. 1867.

50 LIGHTING SETUP FOR PORTRAIT PHOTOGRAPHERS

Steven H. Begleiter

Filled with unique portraits and lighting diagrams, plus the "recipe" for creating each one, this book is an indispensible resource you'll rely on for a wide range of portrait situations and subjects. $34.95 list, 8.5x11, 128p, 150 color images and diagrams, index, order no. 1872.